A History of
WHITBY
& ITS PLACE NAMES

Colin Waters

AMBERLEY

First published 2011

Amberley Publishing
The Hill, Stroud
Gloucestershire, GL5 4EP

www.amberleybooks.com

British Library Cataloguing in Publication Data.
A catalogue record for this book is available from the British Library.

ISBN 978 1 4456 0429 9

Typesetting and Origination by Amberley Publishing.
Printed in Great Britain.

INTRODUCTION

A number of years ago, while teaching local history to adult college students in Whitby, I quickly became aware of their fascination with old local place names and their origins. I was constantly asked questions such as how a street got its name, why it had changed at some point in history, or where a certain place mentioned in an old document or book was situated. Some of these ancient names are still in use by older members of the population who would, for instance, readily identify the Loning as the steep road that runs up beside the 199 steps to the abbey. This name is unrecognised by younger people in the town, who often refer to it as the Donkey Road, despite the fact that this same name is used for another thoroughfare altogether by different residents, namely the winding, steep pathway leading from near the bottom of Church Street to the Ropery.

This appears to have been a continuous process over the centuries in Whitby and district, where old names have changed their spelling and many have become almost forgotten, except in the memories of the oldest residents. Others are only to be found tucked away in the footnotes of ancient history books or have been replaced with 'modern' names, more relevant to the population of any particular era.

This book represents many years of my own sporadic research that has involved dipping into dusty old volumes, perusing ancient maps, seeking out old documents and ceaselessly delving into the memories of many of Whitby's older residents, many of whom have now sadly passed on. A small proportion of entries are taken from modern works, which themselves are based on historical documentation.

Old place name origins are naturally open to further interpretation; so where doubt exists, a question mark follows the entry. Alternatively, the queried fact is noted in the text. Alternative names are indicated by an equals sign (e.g. BRIDGEGATE = BRIDGE STREET = WAYNMAN STREET). Listed dates are not necessarily the earliest or latest that a name

was used, but instead refer to the year(s) found in the documentation that was consulted.

Though a book such as this can never be comprehensive, I hope the entries that follow might at least provide a start in documenting the fascinating history behind the old and obsolete street and place names in this fascinating, historical Yorkshire town.

Colin Waters
Whitby, 2011

A HISTORY OF WHITBY
& ITS PLACE NAMES

ABB CHURCH LANE

(See entry under WHARREL LONING)

ABBEY

The abbey we see now is merely the remains of the abbey church building; the majority of the rest of the associated buildings has long since gone.

It is possible that a number of small abbeys and associated chapels has were built around Whitby, varying from simple wooden cells to the present stone edifice. No one really knows where St Hilda's first abbey was built, and a number of places have been put forward as possible sites, including Flowergate Cross, the site of the Old Abbey Inn (next door to the Little Angel pub in Flowergate), Spital Bridge and Robin Hood's Bay. It would seem unlikely that anyone would build the first abbey on an exposed cliff site, though we must remember that in early days the area may have been forested, as the cliffs have been estimated to have extended a mile or more out to sea in St Hilda's time. Though we don't know how much the 'safety factor' would have been considered by St Hilda's community, it is safe to say that the sunlit valley at Spital Beck would have provided a site that was warm, sheltered and hidden from direct view.

St Hilda came to Whitby in 657 to found her first religious settlement. That abbey, or a subsequent one, was destroyed by Vikings prior to 867. It was in this year that Reinfrid, a 'soldier-monk', began rebuilding the abbey.

The southern part (choir) of the present building was erected by Richard de Burgh, around 1140, following the construction of the chapter house, church, lower tower and pillars. By the late 1300s, architect John of Brumpton (Brompton) was building the north transept, the upper part of

the tower and probably the east wall of the choir. The remainder of the nave was built at a later date using a browner, less durable stone, probably taken from the cliffs rather than from more distant quarries, where it would have had to be transported to Whitby using wooden sleds.

Under fiscal pressure and the threat of an Act of Parliament, the abbey surrendered itself to the Crown commissioners and was officially dissolved on 14 December 1539. If other abbeys are any yardstick, much of the furniture and valuables would have been looted and distributed among the local population or buried in secret hiding places to prevent the authorities from getting their hands on them. Much of what was left was either claimed directly by the Crown or was auctioned off.

Guisborough Priory suffered a similar fate to Whitby only eight days later. Following the dissolution, the monks and priests were pensioned off, given civilian jobs or set up farms or businesses of their own elsewhere.

When the Cholmley family came into possession of the abbey lands, they started using the stonework and roof lead to rebuild the abbot's house as Abbey House (also known as Whitby Hall). It would seem that from this point onwards the rest of the building materials were either given or sold to all who could make use of them. It is not inconceivable that there are still many of the old stone houses in the town that contain much of the abbey structure, and it is known for certain that much of the abbey's lead roof was used to replace the thatch of St Mary's parish church, and two sacred 'blue stones' were also removed from the abbey to the church. There are also a number of gardens in Whitby that still have bits of the abbey built into their walls, especially in the form of parts of carved fluted columns. Similar stones have been revealed during repairs in the walls around the parish church and the surrounding fields on the Abbey Plain as far as Green Lane. In 1817, two circular, stained-glass windows rescued from the abbey were in the possession of William Skinner Esquire and another piece of glass featuring 'a parrot on a sprig' was set into the window of a painter's shop in Bennison's Yard.

The south wall of the nave had already collapsed in 1762, and in 1830 the abbey tower fell a day after a local chimney sweep had climbed it to retrieve the copper weather vane for a bet. On 16 December 1914, a German bombardment from the sea destroyed the main 'great western doorway' and the building was left to decay.

Various parts have been repaired or rebuilt over the years, including one pillar in 1790, but it wasn't until 1930 that a little excavation and repair work was undertaken and the building was finally taken into national care.

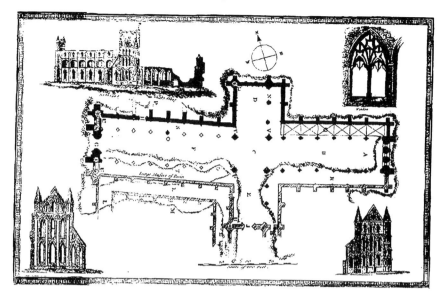

An old plan of the abbey showing the tower and great western doorway still intact.

ADPEDEN PONTIS = PONT GARTH

An area close to what is now called 'Boots Corner'. In medieval times, a packhorse bridge existed here and possibly a bridge chapel. A small bridge was unearthed and reburied in modern times at the bottom of Golden Lion Bank during the digging of a ditch for the new Pier Road sewer pipes.

AIRYHILL = ERGUM HILL = AIRY HALL = ST COLUMBANS = PROSPECT PLACE (1847)

Various names have been applied to the large building on Airy Hill at the north-west side of the new high-level road bridge across the Esk. Two houses have existed with the same name, probably both on the same site. The second, rebuilt by Henry Moorsholm in 1815, is said to have had a tunnel connecting it to the harbour. Airy Hill is a corruption of its earlier Scandinavian name 'Ergum Hill', meaning Summer Pasture Hill, a name that possibly dates to Viking times. The name Prospect Place is directly connected with the fine views once said to be had from Prospect Hill before building took place, and it should not be confused with Prospect Place on the eastern side of the Esk.

AISLABY

This village is known to have formed part of the route of the Roman road from York, via Wheeldale, towards Dunsley (then possibly a wider

Rural crossroads at Aislaby in the 1800s, with the road to Egton (left) and another towards Skelder.

geographical area incorporating nearby Goldsborough Roman signal station). The village name, like others in the district, appears to have Scandinavian origins. *Hassel By (en)* means Hazel Town in Danish. In the 1820s, it had a population of about 250 and was the country seat of John Benson and Mark Noble.

AISLABY QUARRY

The former village quarries provided stone even in the early days of Whitby abbey. Many of Britain's major edifices, including the old London Bridge as well as Ramsgate and Margate piers, were constructed from Aislaby stone, which would be taken to ships in Whitby harbour using wooden sledges towed by oxen.

AISLABY CHAPEL

Aislaby chapel was ruinous from 1653 to 1732, then rebuilt as a chapel of ease connected to Whitby parish church.

ALDERS WASTE GHAUT = AUDERS WASTE = AWDERS WASTE = VIRGIN PUMP GHAUT

This is the slipway on Church Street that descends to the harbour between the public and ticket holder's car parks opposite the Endeavour public house (formerly the Imperial Hotel). Lord Cholmley, a former lord of the manor,

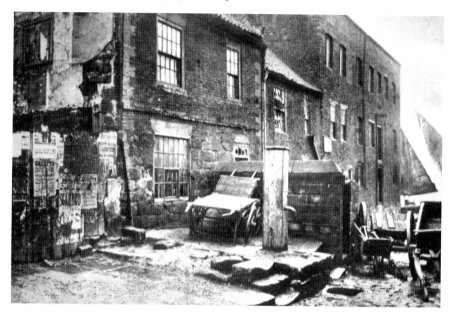

Alders Waste and the Virgin Pump as they once were. The buildings containing Harker's coal warehouse were destroyed by fire.

was once fined for not clearing out the waste that acted as the overflow for the water supply from the Abbey Well, in Jacky Fields. The watercourse can still be seen running down the bank, near the steps, on the pathway known as 'Monks' Trod', which is modern, having been constructed in recent years. This pathway leads from the top of Bridge Street in an area once called Well Yard, up to Back Lane (the footpath leading from Boulby Bank to the parish church). Back Lane was once wider, as far as the end of Aelfleda Terrace, and its cinder trackway was used by horse-drawn vehicles and occasionally even small, early motor cars.

The fresh water coming from the Abbey Well was at one time gathered into a reservoir and served a pump in Alders Waste known as 'the Virgin Pump'. The word 'virgin' in this case is probably a reference to Abbess St Hilda. A number of other wells were once dedicated to her in this district, including the one in the churchyard at Hinderwell (formerly Hilda's Well). The risen square situated at the top of the present slipway at Alders Waste marks the place where the pump stood.

ALLINGTONS LANE = ALLINGTON LANE = ANNINGTON LANE = ELLERBY LANE (modern)

This narrow alleyway, named after a former resident, was once much wider and formed part of the main thoroughfare from what is now the bottom

of Flowergate, via stepping stones or a bridge, through Fish Ghaut (now bricked up), up Ellerby Lane and through White Horse Yard to the abbey.

ALMS HOUSE CLOSE = FERMERY CLOSE = INFIRMARY CLOSE = FERMERY HOUSE CLOSE (prior to 1600) = JACKASS FIELDS (prior to 1950s) = JACKY FIELDS (1950s onward) = DONKEY FIELDS (modern)

The field in front of the former Youth Hostel building at the top of the 199 steps was probably the ancient equivalent of the abbey car park in the days when visitors arrived at the abbey by jackass. Parts of the former Youth Hostel building are believed to have been used in former days as the abbey almshouse, hence its name. A theory exists that there is a hidden undercroft running the full length of the old Alms House/Infirmary buildings.

It is interesting to note that a plot of land called Fermery Close also existed near Spital Beck (the stream that passes under Spital Bridge). This was possibly connected to the medieval Abbey Hospital that is documented close by. Its Master was Robert Alnetto, also known as Robert D'Alney.

ALUM QUAY

Alum Quay was a stone quay and harbour built at Saltwick to serve the alum trade. Its outline can still be seen at low tide. Alum works were first started in the Whitby district in the Kettleness cliffs area, allegedly using foreigners with expertise. These people were smuggled into the country, much to the Pope's displeasure because the enterprise broke his monopoly in the industry. Many other alum works sprung up around the town, and at one period, human urine was bought from local residents at 'slop shops' for use in the alum-making processes. In 1778, Yeoman's Alum Works were described as 'on the lane'. A house owned by a Mr Noble Dale stood nearby. Saltwick Alum Works were unused between 1706 and 1755, and were then reopened by Ralph Carr, John Cookson, Richard Ellison and Jonas Brown. All were listed as part owners in 1788.

AMERICA SQUARE (1817)

This was described as being 'situated in Baxtergate being much bigger than Linskill Square'. It must have been either Wellington Road or Station Square. There has been speculation that its construction was funded by someone who made money from the Californian gold rush, but this cannot be true as the gold-rush years came much later than 1817.

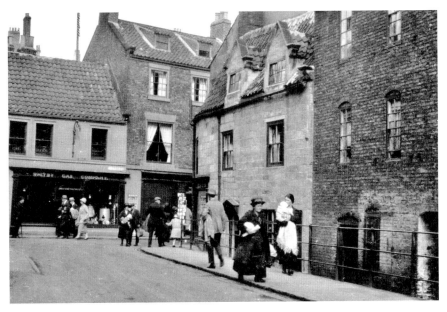

Wellington Road at its junction with Baxtergate looking towards what is today, in 2011, the Heron Frozen Foods shop.

ANDREW'S SAIL LOFT

Samuel Andrew's business formerly made sails in the large building that stands on the harbour side near the old Spital Bridge (*c.* 1850s); it is now apartments. Samuel's son, Robert V. Andrew, was running the business in 1874. The building was, in more recent years, used as the Ship Yard Club – a music and dance venue – that later stood derelict. The building was situated on a site where a Knights Hospitaller hospice or hospital dedicated to St John once stood. Once, it reputedly had a tunnel that led to Whitby Abbey. Until the 1990s, a large, white, hand-painted advertisement sign was still visible on the north side of the building, with Samuel Andrew's name upon it.

ARGUMENT'S YARD

The name of this yard in Church Street catches everyone's attention. Its origins, however, have nothing to do with quarrelling and simply reflect the name of a previous owner, Mr Argument.

ARUNELLS = ARUNDALE HOLE

Situated in Stakesby Vale, close to where the former West Cliff to Whitby railway bridge once stood, are two large metal gates. These once provided the opening to the carriage driveway leading to the Harrowing

Estate in an area of land that included Arundale Hole. Whitby's first ropery, making ropes for local ships, was situated here. It was owned by a Mr Harker, who, together with his wife, was frozen to death in an open horse-drawn carriage during a snowstorm somewhere between Whitby and Scarborough. It is said that when the couple were discovered, their dead horse was found to be frozen in a standing position. 'Mr Goodwill' owned the same ropery in 1828.

On the lowest part of Spring Vale, itself part of Stakesby Vale, there was, prior to the construction of the present bungalows, a small wood containing a small, natural rain pond, possibly fed by the spring that gave the vale its name. On the opposite side of the road, where the row of bungalows now stands, were fields belonging to Field House in Upgang Lane, where a number of long-haired highland cattle grazed in the late 1950s.

ASHES = THE ESHES

This large area of ground consisted of the whole western side of what is now Brunswick Street. It is possible that the area took its name from ash trees growing on the site, but it is also known that tree bark was burned here for use in the 'barking' process of waterproofing fishing nets. A series of small plots known as Barkhouse Garths stood nearby and a number of 'barking pits' were available in the town for the use of fishermen to soak their nets, including one at the back of the Fleece public house on Church Street. Its landlord from 1878 onwards was Paul Stamp.

BAGDALE = BACKDALE (1393) = BAGGEDALE (1700s) = BOGDALE

In 1700, it was listed as being '200 yards long as far as the house of Mr Cornelius Clark or 400 yards long as far as Bagdale Manufactury or 300 yards to Field House, the mansion of Christopher Richardson'. Its name is variously attributed to being a corruption of Bog Dale or Back Dale. The small Quaker burial ground established in 1659 is situated here, unobtrusively hidden behind a wall close to Pannett Park.

BAGDALE BECK = BACKDALE BECK = THE SLYKE

The Slyke refers to the small, open stream that ran, and still runs beneath the road, down Bagdale, emptying into the harbour at Dock End near the railway station. It was tidal as far as Bagdale Brewery. In the early 1800s, it was still possible to fish from the houses around what is now Victoria Square. During heavy rain or high tides the stream swells in size, and buildings in Linskill Square, Station Square and surrounding areas are still subject to flooding.

Bagdale in the 1700s, with the Slyke stream partially covered by a culvert on the right.

BAGDALE BREWERY

On 16 November 1888, this was advertised for sale, complete with brew house, malt house, cart sheds, stables, yard and gardens, with the remainder of a 1,000-year lease dating from 1639. It stood at the back of what is now Broomfield Terrace, the site later being used by Mr Hodgson's Bagdale garage.

BAGDALE BRIDGE (1817)

A footbridge that had replaced earlier stepping stones crossed the beck – a local name of Scandinavian origin for a small stream – at a point where Spring Hill meets Bagdale in Victoria Square. The stream was once open all the way to Factory Fields. The remains of an arched bridge, which once crossed over the stream, were recently found when the retaining wall to Carr's Yard was repaired. The raised, high walkway on the northern side of Bagdale was constructed to allow pedestrians to negotiate the side of the stream, which proved impassable in times of rainy weather, reputedly after a man drowned there.

BAGDALE 'OLD' HALL

The building was known as Bagdale 'Old' Hall, even in the 1700s, and had a reputation as being the most haunted building in Whitby. In 1734, its lands (the Bagdale estate) included gardens, a bleaching garth, the 'Great

Pasture', a cottage and other pastures stretching from Backdale Beck to Bog Hall, including Spring Hill and the site of the present railway station. The owners of the hall at that time also owned the Horse Mill in Horse Mill Ghaut, Baxtergate, close to what is now known as Boots Corner. This Horse Mill was possibly used to drive a mechanism to open and close the bridge. It was still in existence in 1817. At that time, the building was used for grinding malt. In the same area was a house belonging to Christopher Richardson, which was being used as wine cellars. This is probably the same building later used by Falkingbridge & Son for the same purpose and marked on old maps as the original St Ninian's chapel.

BAGDALE MANUFACTURY = CAMPIONVILLE (1828)

Campionville was a sail and cloth factory that stood at the entrance to Factory Fields, hence the name. It was used during a war with France as a sail-making workhouse, which used captured French prisoners as its workforce. In later years, the building was used as a school-meals kitchen (1950s), Sewell's sweet wholesalers (1960s), and more recently Beevers carpet and furniture warehouse.

BAGDALE PUMP (1800s)

This water pump stuck out into the road at the bottom of Union Road (now Union Steps), Bagdale. It was noted for its noisy mechanism, which brought regular complaints from those who lived nearby.

Another view of Bagdale showing the public water pump at the foot of Union Road (now Union Steps).

BAGDALE SPA

This round building containing a spring of water and a pump was promoted in the Victorian period as a health spa. The building still stands, though now hidden away at the back of Broomfield Terrace. It is occasionally opened to the public by the local Civic Society.

BAGDALE TERRACE

This is the name for the row of buildings in Bagdale that stretches up the south side of the street from Bagdale 'Old' Hall towards Broomfield Terrace.

BAKEHOUSE GARTH (1654)

This was a plot of land near Flowergate, opposite the top of the present Brunswick Street, which was built upon to create Waterloo Place and Waterloo Yard (later the site of the former Waterloo Cinema). It may have extended as far as Cliff Street, as the name is also mentioned in connection with a piece of land situated there in 1654.

BALD(S) BY LANE = BALDERBY LANE/BALBY CLOSES = BALDBY CLOSES

The name has Viking origins, *Balder* being a mythological Scandinavian god who was the son of Odin and Frigg. In 1541, Balderby Closes consisted of 80 acres 'lying near Staxby' (Stakesby). It comprised four separate closes, though the name was going out of use in 1817, when the area stretched from the top of Waterstead Lane to the Turnpike Gate on Mayfield Road. Remains of the turnpike payment booth and castellated wall can still be seen, together with one of a pair of walls that once formed a chicane for traffic queuing up to pay their toll.

BALK

Not a name but a feature often found on old maps. It was once a common term for any dividing ridge or furrow separating two areas or ownerships of land.

BANJO COTTAGE

This old cottage, equipped with only an outside dry toilet, stood close to the bend near the entrance to Ewe Cote on the road from Stakesby towards Middlesbrough. A modern bungalow now stands on the site. There are a number of theories as to how it got its name. None are conclusive, but we

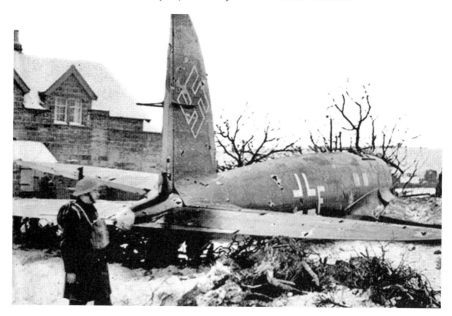

Bannial Flats. A soldier guards the first German plane to be shot down in Britain during the Second World War.

do know than the fact that a banjo was a short-handled shovel, often used by miners (possibly to clean out the toilet).

BANNIAL FLATS

A First World War 'first' for Whitby was the shooting down of the first German plane on British soil. It was brought down at Bannial Flats by Group Captain Peter Townsend, who later came to fame when he was romantically linked to Princess Margaret, sister of Queen Elizabeth II.

BARKER'S QUAY

A small quay situated next to Mr Barker's timber pond. It stood between the bottom of Waterstead Lane and Dock End. Behind it was Barker's Ropery (see under ROPERY WALK).

BARKHOUSE GARTHS

These were plots of land once situated at the west side of what is now Brunswick Street and stretching the whole way between Bagdale and Flowergate. Barkhouse Garths formed part of the area known as the Ashes. This may have been the same area that was known as Bake House Garth in 1654.

BATH LANE (1828)

Pier Lane, the path from Cliff Street to the seaward end of Haggersgate, took this name when the town's first public baths were built on Pier Road.

BAXTERGATE = HIGH STREET = VIA REGIS = KINGS HIGHWAY (1514)

Baxtergate may have been named after a family called Baxter who owned property there, but the name may equally be derived from Back Stair Gate – 'stair' meaning a way up, rather than actual steps. It has been recorded that a family named Baxter lived in the street in 1592, though the earliest use of the name Baxtergate is not to be found until 1616. Bagdale 'Old' Hall at its extreme end was described in the 1700s as 'just outside the town' (in Ruswarp). The Whitby/Ruswarp boundary still runs across Victoria Square, up Brunswick Street, through the middle of the Little Angel pub and beyond. A boundary plaque marked 'W.R.P.' – Whitby and Ruswarp Parishes – can be seen on the Little Angel. Another marker, now badly worn, is on the gatepost leading up the footpath from Spring Hill to Meadowfields. Halfway up that path once stood a small obelisk, also a parish marker that was taken away by someone in recent years, possibly as a garden ornament. Obviously, they are blissfully unaware that the boundary between Whitby and Ruswarp now runs through the middle of their garden!

Baxtergate has always had its fair share of public houses. A pub song, very popular in former days, referred to the fact that those out of work would hang about on the street of Baxtergate, hoping to bum (scrounge) a beer from someone. One verse ran:

> Bumming for ale boys, bumming for ale.
> Sometimes they get some and sometimes they fail.
> Just look at their noses, as red as the roses.
> Bumming on Baxtergate. Bumming for ale.

BAXTERGATE BAKEHOUSE

A public bakehouse in Baxtergate was owned by Joseph Gibson in 1778.

BAXTERGATE FOUNDRY

This was an iron foundry owned by George Chapman, who manufactured a cast-iron gravestone for himself, his wife Elizabeth and their children Esther, Edward and John William. This rare example of a cast-iron tombstone can still be seen in the north-east corner of St Mary's graveyard.

Belle Island (left) does not exist any more and virtually all of these buildings that lined the east side of the harbour have also vanished.

Another, or perhaps the same, iron foundry is recorded as being at 'Dock End' and owned by Richard Vipond in the early 1800s.

BELLE ISLAND = BELL ISLE = BELL ISLAND

A large, bell-shaped area of mud that is visible in many old photographs of Whitby's upper harbour. It was removed when redevelopment of the marina was planned. In Baxtergate, the Belle Hotel (now flats above a fruit shop opposite) took its name from it, residents having the questionable pleasure of viewing the mud from their bedroom windows.

BEREWICK

This term is sometimes found on old maps to describe a group of houses or a hamlet.

BLACKAMOOR(S)

This was an old name for moorland such as the 'Cleveland Blackamoor' that extended from Whitby to Middlesbrough.

BLACKLOCK'S SCHOOL

A private school owned or run by a Mr Blacklock, situated somewhere near the harbour (or alongside Bagdale Beck) in the 1800s. Pupils were able to fish from the windows of the school.

BLACK NAB

This is a large, black shale prominence that sticks out into the sea near Saltwick. The names 'nab', 'neb' and 'nib' are old English words meaning nose, beak or prominence. The word 'nab' can also mean a trap. Black Nab once stood as high as the cliffs, but it is now greatly eroded by the sea. It was once a popular area for gathering periwinkles – sea snails – which were eaten boiled and sometimes soaked in vinegar. In the 1700s, they were shipped in relatively large quantities from Whitby to markets in London, as well as being part of the staple diet of some local families. Locally they are known as winkles or cuvins.

BLEACHING GARTH

A property attached to Bagdale Hall in 1734 and probably utilised for bleaching linen used for making sails.

BLUE ROBIN (1800s)

A colloquial name given to the former Raven public house at Ravenscar. It mocked the poorly painted illustration of a raven on its sign.

BOARD SCHOOL

Once situated on the riverside in Church Street on a site just south of the former St Michael's church, this school was run by a board of governors

In the late 1800s, New Quay Road was still a large dock area. Directly opposite can be seen St Michael's church and, to its right, the Board School (the tall building).

and had steps from the road leading down to a walled playground. It stood opposite the entrance to Primitive Methodist Chapel Yard, but was demolished, along with many other buildings on the harbour side, in order to widen the lower part of Church Street.

BOBBIES BANK

This was formerly a grassy bank with long, shallow steps, edged by metal railings, and a gate. It was entered through two large stone gateposts at its bottom entrance and was situated between Station Square and Whitby Public Library, emerging near the police station and hospital on Spring Hill. It could easily be negotiated by a woman pushing a pram, but was later replaced by the present steep steps when the modern unemployment office and block of shops were built. The bank took its name from the fact that it was used by policemen stationed at an earlier police station situated in premises at the bottom of the bank.

BOIL HOUSES

A number of boil houses lined the River Esk in the days when Whitby was a whaling port. Their purpose was to extract oil and other by-products from whale carcasses.

BOLTING MILL = RUSWARP MILL

A large bolting mill used for sifting meal and grain was erected at Ruswarp in 1752. It later became known as Ruswarp Mill.

BOLTON'S STEPS (1828)

This is the double set of steps, still in existence, leading from the south end of St Ann's Staith into the harbour. It appears that a tunnel, perhaps leading to a slipway, once existed between the steps at water level. The name comes from a Mr Boult or Boulton, who was landlord of the nearby Brown Cow Inn in 1823.

BOOTS CORNER

This now demolished block of buildings was situated at the south-west end of the old bridge across the Esk. Its colloquial name came from a branch of Boots the chemists that stood on the corner of the street. The block also housed Gray's draper's and before that a public house referred

to as the Randyv House, which was used as a gathering place for the press gang. It was supposedly burnt down during a riot in 1793, when an innocent old man was hung at York for shouting encouragement. Though the incident is factual, other documentation places the Randyv House pub in Haggersgate. The ancient Latin name, *Adpeden Pontis*, probably signifies Bridge End or Bridge Entrance.

BOTHAM = BOTHOM

Formerly a farmstead at the place now called Hawsker Bottoms.

BOULBY BANK

Boulby Bank took its name from Mr Boulby's Ropery. The bank was once much wider and was well known for its tenements accessed by wooden walkways. The roughly square, sloping plot of land between these buildings was used for various purposes, including the drying of washing, and garden plots.

BOULBY SLIP (1828)

Boulby Slip was a slipway leading down to the harbour. It was situated opposite the entrance to Boulby Bank.

As can be seen from this Victorian photograph, Boulby Bank occupied a much wider area than its modern counterpart.

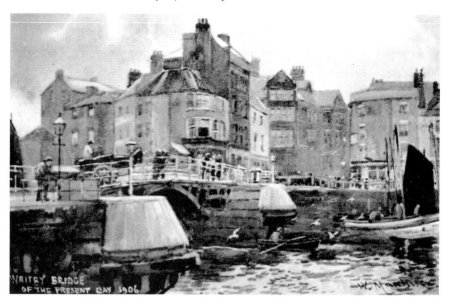

Boots Corner (the ancient *Adpeden*) as it was in 1906, when the old bridge was still in position.

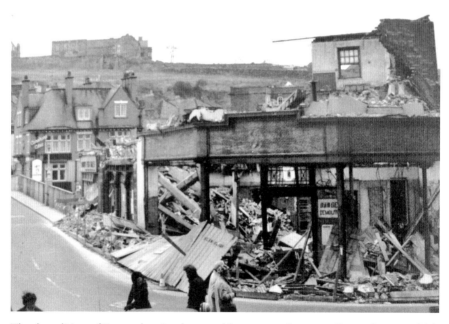

The demolition of Boots chemist shop could not erase the name, Boots Corner, which is still in common usage.

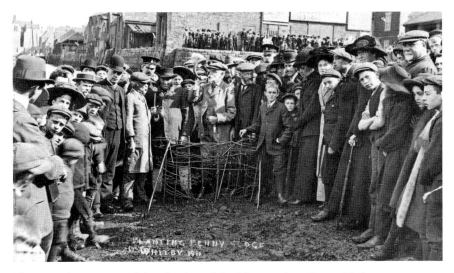

The annual ceremony of the planting of the Horngarth or Penny Hedge, 1911.

BOYES STAITH

This staith or small pier stuck out into the harbour in lower Church Street and was owned by a Mr Boyes. The mud below it was once the traditional site of the planting of the Penny Hedge or Horngarth ceremony, which still takes place on the Eve of Ascension. Despite a legend linking it to the murder of a hermit, the custom probably derives from a fence placed at the harbour's edge, where animals were driven for de-horning. One of the oldest buildings on the lower end of Church Street, now used as a motorcycle garage, was formerly called 'Horn House'.

BRECCA

Mentioned in abbey deeds, it probably refers to Breckenrigg – Bracken ridge – near Ewecote, on the Castle Park to Cross Butts road.

BRIDGES

Local children were once always asked the riddle: 'Where in Whitby do you get wet and dry waters together.' The answer was: 'When you go over the bridge.' The explanation for this is that Whitby Bridge had a bridge waiter, surnamed Waters, who was known for his loud call, 'Keep to the right', aimed at people crossing, prompting a local pub song:

Ain't it a fine construction
We've prayed for its destruction

From morn til night it's 'Keep to the right'
Ain't it a fine construction

There's waters down below and Waters on't top
He walks from side to side and nivver spills a drop.
From year to year it's the same old cry
The water's wet but Waters is dry.

The bridge waiter's job was to help guide sailing ships through the bridge and to aid carts with high, wide or unsteady loads over it. In strong winds a rope would be thrown over high loads and two bridge waiters would hang on at either side to prevent it being blown over.

Though Whitby now has a high-level bridge, its other known crossings were as follows:

- Medieval times – A stone pack horse bridge crossed close to the present one. Remaining arches were discovered in recent years at the foot of Golden Lion Bank and were left in place after the laying of a new drainage system for the town.
- Up to 1630 – A wooden footbridge at Stone Quay (bottom of Waterstead Lane).
- 1630 (some accounts say 1610) – The wooden bridge at Bog Hall was demolished and a wooden drawbridge erected at the present site.

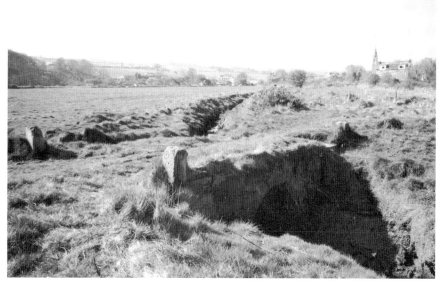

Now overgrown and barely visible, this old packhorse bridge is hidden away on Ruswarp Fields, close to the former river crossing to Glen Esk.

- 1766 – Wooden drawbridge rebuilt with stone piers.
- 1775 – Spital Bridge was rebuilt.
- 1835 – New Swivel Bridge built. It had been proposed in 1813 together with plans to build the East Pier lighthouse.
- 1909 – Present Swivel Bridge built.

Further upriver, close to Fitz Steps and across the railway line near the swing gate that divides the Ruswarp to Mayfield Road footpath, is a small overgrown and almost hidden packhorse bridge. It possibly formed a route over to Glen Esk at the shallowest part of the river.

BRIDGE STREET = BRIDGEGATE = WAYNEMAN STREET = BRIDGEGATE = BRIDGEGATE = BRIGATE

All the properties on the south side of Bridge Street from the present *Whitby Gazette* offices to the top were once called Wayneman's Buildings. Grace Wayneman owned a public house on the site, possibly the building occupied today by the *Whitby Gazette*. She was renowned for selling 'Bumbo' – smuggled spirits brought in by local 'bumboats' from vessels waiting in the bay. Local dignitaries are said to have comprised the bulk of her customers.

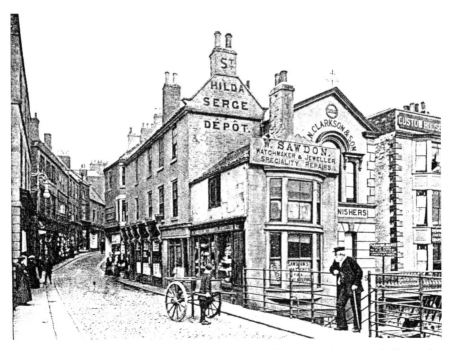

Bridge Street before it was widened. The white building behind the two ladies in the distance is the present *Whitby Gazette* premises.

BROAD DYKE

These are lands around Sneaton village, mentioned in old charters. Its name is self-descriptive and probably refers to a boundary ditch.

BROWN'S QUAY

Jonas Brown had a shipping business in 1755 with a fleet of ships that travelled as far as America. He traded in herbs and spices between Whitby and settlements in Virginia. From the wording of his will he appears to have not always stayed strictly within the confines of the law. His 'herbs' probably included undeclared tobacco. He lived in the tall house with the bottle window at 19 Grape Lane. The building is said to be built on a plot of land left to him by his aunt. With Brown's new-found wealth he demolished the old house and built the present one, possibly leaving the cellar with its original fireplace. A water cistern used to supply the house with water was discovered in the present yard in the 1980s. Behind this house was Brown's Quay, where he moored his ships. One of his vessels, *The Whitby Packet*, was bought from Lister & Pack, London, and was later used to transport a new peal of bells to Whitby for use in the parish church.

BUMMALKYTES LANE = BRAMBLE LANE = BLACKBERRY LANE

This lane on the outskirts of Whitby was once popular with blackberry pickers. Like the word 'bramble', 'bummalkyte' was another name for a blackberry.

BURNTHOUSES

Unidentified but described as 'an area where was built the house of Mr. Reynolds'. This may or may not be the same location as Burnthouse Farm, not far from the village of Lealholme.

BURTREE CRAGG = BUTTERY CRAG (prior to 1690) = SKATE GATE = THE CRAG (modern)

Until 1608 the Crag was known as Skate Gate. The modern name 'Cragg' is a contraction of Burtree Cragg, a craggy outcrop once covered with short deformed trees containing burls or burs (due to their close proximity to the North Sea winds). The name became mistranslated as Buttery Crag and it appears as such on some maps. A landslide in 1900 destroyed two houses and resulted in the death of a young mother and her child. Others were said to have died later 'from shock'. Prior to the 1900s, the Pier

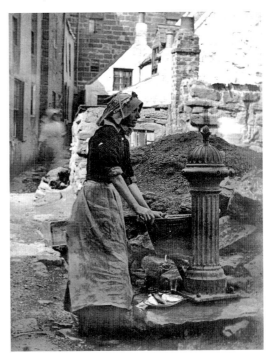

A woman washing fish at the
Pier or Crag Pump.

Pump (also known as the Crag Pump) stood at the top of the present small
flight of steps leading from Pier Road to the Cragg (opposite the present
Fish Market). The next nearest public pump on the west side was said at
that time to be the one in Bagdale. Number 16 the Cragg once contained
a sail loft, and its basement was formerly used as a lock-up. All houses
alongside the Cragg on the Pier Road side were previously connected by a
loft-tunnel, reputedly used for the movement of smuggled and illicit goods.
This led from the Pier Inn, which had a concealed room entered through
the back of a wardrobe.

CALIFORNIA = NEW GARDENS = BOTANIC GARDENS = FOLLY GARDENS

This area to the south of Green Lane running alongside Spital Beck was
earmarked for the construction of botanical gardens in the 1700s, because
of its sheltered, sunny position. Later, in the days of the California gold rush
(*c.* 1849), digging activity was so strong that locals dubbed the area
'California'. The small rivulet strictly called Spital Beck which runs
through the valley, is still called 'California Beck' (colloquially 'Caller
Beck'). Ambitious plans to grow tropical fruits, plants and vegetables in
the new botanical gardens came to little and the idea was dubbed 'a folly'
(hence the other name for the area: Folly Gardens). Two local families
involved in this or a similar venture in 1812 were the Willisons and the

Hunters. Both failed but went on to establish successful greengrocery and flower-growing businesses.

CAMISEDALE

This ancient name for Commondale in old charters may reflect a battle having being fought there, as a *camisade* was an attack made by military forces after dark.

CANAL, THE

A canal was cut by Nathaniel Cholmley in 1778 at a bend in the River Esk. It stretched in a straight line from the riverbank at Glen Esk towards Fitz Steps on the Mayfield Road – Ruswarp footpath. Its purpose was to make the river navigable for transporting goods from Ruswarp Mill to Whitby. Remains of the edge of the canal can still be seen at low water.

CARRIAGE CLOSE

In 1541, this was described as being three closes or 4 acres of land including part of 'The Knolls'. It had a hedge boundary that was described as 'still visible' on account of it forming part of the salt works at Saltwick. In 1778, The Knolls, together with Carriage Close and Garden Close, were owned by a Mr Yeoman.

CARTERS SHEDS

These were part of the blacksmith's shop and yard once situated in lower Church Street on a site now occupied by a fish and chip shop, just south of the entrance to Boulby Bank.

CASTLETON

Anciently, Castleton was part of Danby. It is described as a 'new' market village in 1715, when it was built close to the remains of its now vanished castle. According to local tradition, the castle on Castle Hill was destroyed by fire and the materials were reused to build the village church.

CHALLICE HOUSE (1716) = CALLICE HOUSE = CHAPEL HOUSE (1817)

A building that was itself, or was attached to, the original St Ninian's chapel on the harbour side of Baxtergate, close to Boots Corner. It was first recorded in 1595. In 1817, it still had an attached garth (piece of

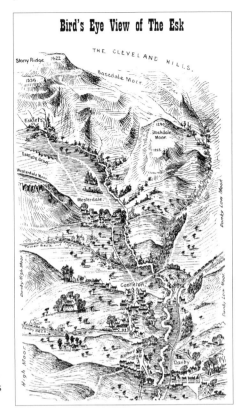

This unusual old map shows Castleton in relationship to other Whitby villages that stretch up the Esk Valley.

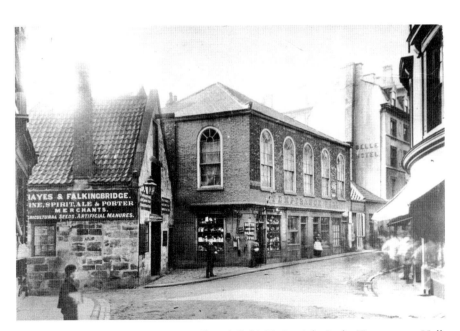

The old Chalice House/St Ninian's Chapel (left). To its right is the Temperance Hall, now the HSBC bank.

land) and was described as having tenements and shops nearby that projected into the street. These premises were owned by Adamson and Cockburn (see Young's *History of Whitby*). Two years earlier in 1815, William Chapman had erected a house on the site next door. During the construction, workmen discovered old foundations with carved stones. These were evidently reburied without any recording or examination. This evidence seems to confirm that the original St Ninian's was a medieval bridge chapel. It would also appear that the building seen on some old photographs as Falkingbridges wine store and seed wholesalers was at least in part both the Challice House and the original St Ninian's chapel.

CHURCH STREET

Once Whitby's main trading street. No street in Whitby has had more names, due to the fact that it has not always been one continuous road, but rather a series of strips of road, joined by tracks or wooden wharf ways across the sandy riverside. It had a number of 'Horse Roads' or 'Donkey Roads' leading from it and once petered out at the bottom of Boulby Bank in an area known as 'Town End'. The names used for the various parts of Church Street were:

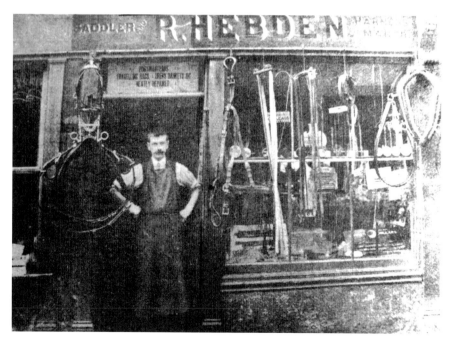

Robert Hebden, saddler and harness-maker, was one of many sole traders who had small shops on Church Street in the early 1900s.

The buildings in the Tatie Market are no more, though the cobbles in this old photograph can still be seen at the present bus stop.

CHURCHGATE: All of Church Street as we know it. The word 'gate' means simply a way into town and not necessarily a wooden or stone gateway.
CHURCH SOUTHGATE (1750s): An alternate name for Southgate (see below).
CHURCH STAIR FOOT: The open area at the bottom of the 199 steps. (There were 190 steps or 'stairs' in 1778.)
CROSSGATE (1750s): Grape Lane to Bridge Street.
FAIR AISLE (1725): From Alder's Waste to the end of Grape Lane – a cobbled area extending sideways from the road and further down Church Street. It was the place where fairs were held in ancient times and where the Viking *Thingwalla* or town hall was first erected. The medieval town hall or 'Tollbooth' stood here before transference to the Market Place further up Church Street. This area was also used as the 'Potato Market', also known as 'Tatie Market' (pronounced Tay-tee), and has retained both names into modern times.

When this photograph was taken in the early 1900s, the term South Gate was obsolete. Today, virtually all the old waterside buildings have gone.

HIGH GATE: The top part of Church Street from Bridge Street to the sea.
HIGH STREET = HIGH KIRKGATE = KIRKGATE: All of the joined parts of the street in earlier times, although Kirkgate appears in documents as early as 1318 and as late as 1730.
NEW QUAY: A new quay was built on the harbour side in the 1820s at the north end of Church Street on the harbour side, where the road narrows at New Way Ghaut. Its purpose was to connect the fish pier to Tate Hill Pier.
NEW WAY & NEW WAY GHAUT: This New Way came in to being at the same time as the New Quay mentioned above.
LOW STREETS: Grape Lane and Sandgate were jointly given this name either in the days before they were individually named or simply to distinguish them from the High Street.
SOUTHGATE (1750s): Alder's Waste/Grape Lane end to Wood's Quay.
THINGWALLA: Situated in Fair Aisle (see above). According to the oldest maps, it seems to have been at the centre of ancient Whitby.
TOWN END: Once considered the southernmost end of Church Street. Here a wicket gate stood somewhere near the bottom of Boulby Bank.
WOOD'S QUAY = WOOD STREET = WOOD'S STAITH = JOSEPH WOOD'S STAITH: The area around the bottom of Salt Pan Well Steps (see separate entry).

CINDER LANE = ARGYLE ROAD

The former name of Argyle Road before it became an official street was Cinder Lane. It was a muddy track covered in coal cinders.

CLAIRMONT HOUSE = CLAREMONT HOUSE = CLAREMONT LODGE

This was the original name for the building that was enlarged to become Sneaton Castle. It was built in 1813 by the Reverend J. T. Holloway and was expanded and refurbished by Colonel Wilson around 1836. Claremont House took its name from its namesake in Surrey, built in 1708 by Sir John Vanbrugh, the architect of Blenheim Palace and Castle Howard. It is said that Wilson, who is said to have made a fortune from using slaves on his plantations in the Caribbean, copied the design of the castle from an old print of a now vanished castle in the village of Sneaton.

CLARKSON STREET

It was in existence without a fixed name in 1817 and probably took its name from a member of the local Clarkson family who either developed it or simply lived there.

CLAYMORE WELL

A place near Kettleness, which once had a reputation as a meeting place for fairies and other mythical beings known locally as *boggles*. A claymore was a large double-edged sword.

CLIFF STREET = CLIFF LANE = RUSSEL LANE = WINDY LANE = WIND (to rhyme with kind) LANE (1540) = WYND LANE

All are found as old names for Cliff Street. It was upgraded to street status after angry Victorian bed and breakfast owners complained that they were missing out on potential bookings because their address in adverts appeared to suggest that their premises were in a remote lane rather than in town.

CLIFF CLOSES = CLIFF FIELDS

The West Cliff Estate was built upon these fields, which were reached by entering through a wicket gate at the end of the level part of what is now Cliff Street.

CLIFF COTTAGES

The row of cottages still in existence between Botham's and the jeweller's shop at the top of Skinner Street.

NOTICE

1794

AN EXPRESS

STAGE COACH

from the

"White Horse and Griffin" Hotel,

WHITBY

and

Fox and Rabbit Arms, Malton village

WILL RUN

(if God permits)

stopping for refreshment, ale, exercise and Smoaking,

the whole journey in 14 days

All that are desirous to pass to London Stamford or
other Place on that Road; Let them repair to
Henry Goodwood at the White Horse and Griffin.

Fare all Weights and Ages.

8 shillings outside **15** shillings inside

BEGINS ON THURSDAY, 9th APRIL,

Each person allowed 3 lbs. luggage,

No crossing, jostling, and kicking.

PIGS will be turned out.

All last wills should be made before departure.

Above: An old engraving showing Cliff Fields just after they were built upon to form the West Cliff Estate.

Left: The roads around Whitby were a dangerous place in the 1700s, when passengers were advised to make their wills before travel.

COACHING INNS

Coaches called at many of the local inns and taverns, and ran services to York, Hull, Sunderland and even further afield from a number of inns, including the Angel, the White Horse (now the Black Horse), the Turk's Head and the White Horse & Griffin. Early services began in the 1700s and continued until steam trains effectively ended the coaching transport monopoly.

COCK MILL = CORKE MILL = COCK-SHOT MILL (1800s) = COCMYLN

A former water mill in Larpool Woods situated approximately 1½ miles from Whitby. The name may reflect the fact that it was not a conventional 'overshot' or 'undershot' mill, but instead had an angled or 'cock-shot' water race. A farmhouse with a cock-fighting pit was also situated here, giving an alternative origin for the name.

COCKPIT YARD

The last of many yards with cock-fighting pits to retain this name stood on the site of what is now the reserved car park next to the Captain Cook Memorial Museum on Grape Lane. Another cock-fighting pit was once situated in Ellerby Lane. That too was referred to colloquially as Cock-Pit Yard. Cock-fighting also took place in Golden Grove woods.

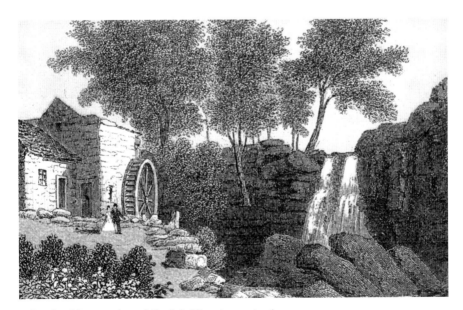

A lovely old engraving of Cock Mill as it was in the 1700s.

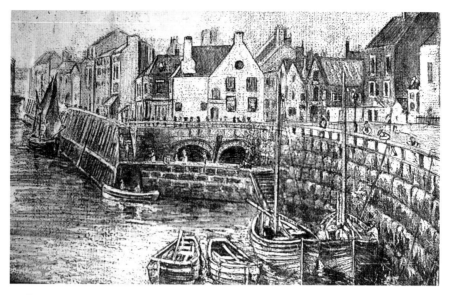

Coffee House End in 1886, and below it can be seen the old pier, which can still be seen today.

COFFEE HOUSE END = PIER END

The end of the pier in former times was situated at Coffee House End, at the seaward end of Haggersgate on Pier Road. The coffee house in question later became the Marine Hotel and public house. By descending the steps down towards the harbour at this point, the distinctive remains of the pier end, complete with a mooring post, can still be seen.

CONDYTH HEAD (1541) = CONDUIT CLOSE (1778)

This was the site of a conduit, which in 1778 conducted water from a spring near 'Mally Smith's House', near Carriage Close, Saltwick.

CORN(E) CLOSE (1737–1775)

Corn(e) Close was a field used for growing corn, situated between what is now Boulby Bank and Salt Pan Well Steps.

CORRECTION HOUSE (& GARTH)

Whitby's 'correction house', where prisoners spent one to thirty days for minor offences, was located prior to 1788 in Flowergate in the building

once used by Seaton Gray, Bell and Bagshawe, solicitors (now Bagshawe's tea rooms). The small cubicle-like cells were still visible in the coal cellar in the 1980s. Behind the building was the exercise yard, known as Correction House Garth. This plot of land stretched along Cliff Street in an upward direction and adjoined Bakehouse Garth in the Waterloo Yard area. In 1788, prisoners were also kept in a lock-up in the 'Tollbooth' (town hall) in the Market Place. By 1817, the lock-up was on 'the Quay' (now New Quay Road). Other lock-ups, or hoppets as they were known locally, have been identified on the Crag, Battery Parade and Marine Parade, in a cellar on the site of the old Empire Cinema (now a Boyes store) and in Blackburn's Yard in the small building that now houses a pottery. A notation in 1816 stated that the local hoppets were barely used 'except for frightening offending youths'. One of the local constables, a former watchmaker named Linskill (father of local writer Mary Linskill), was the butt of jokes from local children because of his having one leg shorter than the other. As he passed by, they would chant, 'Linskill, Linskill, hop hop hop, he served his time in Turnbull's shop.' Turnbull, a local watchmaker/ jeweller, once had premises on Bridge Street, close to the bridge. Joseph Robert Fletcher was listed as living in Lock-Up Yard in 1937.

COUNTY SCHOOL = GRAMMAR SCHOOL = WHITBY SCHOOL = WHITBY COMMUNITY COLLEGE (modern)

This fine old school building has now almost been lost among modern extensions, though it still exists in its original form, including the adjacent round observatory building housing an astronomical telescope. Until recent years, a row of poplar trees lined the driveway, one having been planted for every former school pupil or teacher who lost his life in active service during the First World War.

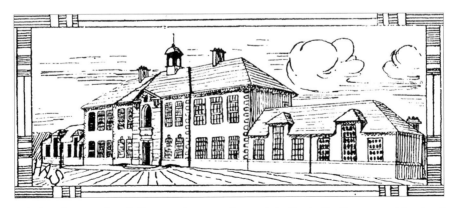

Whitby Community College as it was when originally built (from an old school magazine).

CROSS BAR LANE = SWITCHBACKS

Cross Bar Lane is now known as the Switchbacks. Its hills and dips, which resembled a rollercoaster ride, have now been smoothed out to a great extent. It had the official name Cross Bar Lane in the 1800s, when it linked the Castle Park area to the turnpike road (the 'bar') on what is now Mayfield Road.

CROSS PIPES = CHAPEL INN

This inn at Goathland existed as early as 1615; recorded landlords include Joseph Jackson (1801), John Hill (1881) and John Sleightholme (1890). The inn closed in 1892 and its licence was transferred to the Mallyan Hotel.

CROW LANE

The name was in use for Newton Street in the 1800s, when it was lined with trees in which crows nested.

DANBY = DANEBI = DANEBIA (eleventh century) = DANEBY IN BLAKORMOR (fourteenth century)

The lands of this village anciently encompassed Castleton Dale, Danby End, Little Fryup (long ago known as Frehope or Frihope) and Ainthorp (known as Arnethorpe in the sixteenth century.) It has been speculated that a Danish village was situated in the fields known as the Tofts and the Wandales, north of the church. The remains of the old castle, which was inhabited at one time by Catherine Parr, the last wife of King Henry VIII, are now incorporated into farm buildings, though parts are still intact. Today, the ancient Court Leet still meets annually in one of its surviving rooms.

DARK END (1828) = GRAVING DOCK (early 1900s) = DOCK END (modern)

Dark End was the name for what is now New Quay Road area before any real quay or roadway had been constructed. Stocks for punishing offenders were situated here in the early 1800s. The modern term Dock End (probably a mispronunciation of Dark End, the name used when it was an unlit area of town) is now falling out of use, except by boat users. Graving Dock (dry dock) records a time in history when ships were laid up here for repair.

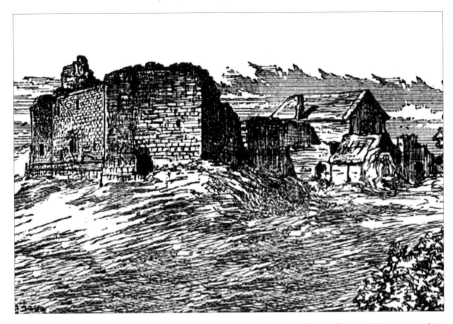

Danby Castle was once the home of Catherine Parr. It is shown here as it appeared in the nineteenth century.

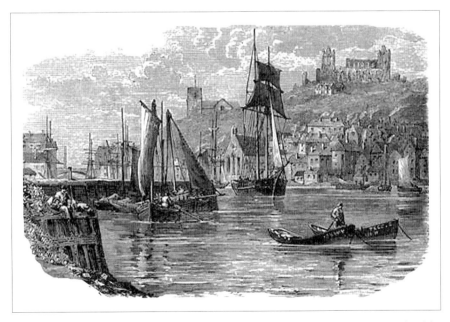

Dark End, now Dock End, was indeed a dark place before the installation of public street lighting.

DAWN DINNER HILL = DOWN DINNER HILL

It is commonly thought that it got its name because railway workers went down it for their dinner; however, history tells us that the area was known as Down Dinner Hills in 1778. The word *Down* in Anglo-Saxon times represented a slope while the word *Dinger* was a Viking word meaning to drive something – such as cattle.

DIVINITY FLAT

This was the flat piece of land at Whitehall shipyard running alongside the eastern side of the river towards the south where a Prussian-Blue dye works once stood. The factory chimney can be seen on old postcards. The origins of the name are lost to history.

DOG LANE = DOG LEG LANE

Dog Lane is still in existence, but it is overgrown and largely unnoticed by passersby since the new harbour-side housing development was built. It once formed a connecting road from the top of Spital Bridge to a ford across the river. Its name is purely colloquial and is derived from its original dog-leg shape.

Now overgrown and disused, Dog Lane was once a well-used road from the top of Spital Bridge to the ford over the Esk.

The remains of a smuggler's tunnel were found at the rear of this building site when the present Boots chemist on Baxtergate was extended.

DOCTOR LANE (*c.* 1677–1710) = LUGGER HEAD YARD = LOGGERHEAD YARD (modern)

The yard's modern name comes from the lugger or logger (ships) figurehead attached to the wall of the old Smugglers Café, said to have originally been taken from a captured French vessel. Supposedly the residence of one or more doctors at one time, the houses along the western side of the yard conceal a tunnel (now sealed off in some houses) leading from the former Cutty Sark public house to the Smugglers Café. The tunnel allegedly carried on along Baxtergate and emerged under the font in the old Unitarian chapel in Flowergate. Though the Baxtergate part of the tunnel was believed to be legendary, remains were found behind Boots chemist when building work was taking place in recent years. A large, square smugglers' hold (only accessible by lifting up floorboards in Talbot Cottage) is known to have existed in the back of the old Talbot Hotel before that too was altered to make way for modern shops in recent times.

DOLLY MORTIMER'S = DOLLY'S = MORTIMERS LODGINGS

A once well-known lodging house on the harbour side run by a local character named Dolly Mortimer. It was reached by a footpath leading towards Ruswarp from the bottom of Waterstead Lane. It was used by fishermen and sailors and had a reputation for being exceptionally clean.

DONKEY ROAD = HORSE ROAD = HEARSE ROAD

There were a number of 'Donkey Roads' in the district. The two that retain the name are on Church Street, one running up the side of the 199 steps, the other starting from between the tyre supplier's garage and the fish and chip shop on Church Street, where it winds its way up to the Ropery near the top of Salt Pan Well Steps. The latter was also called the Hearse Road, possibly because it was used by funeral processions on their way to the parish church. Both Donkey Roads are also confusingly known by the name 'Horse Road'.

DUNSLEY = DUNSLY = DONSLEY (1396)

The village name is derived from *Dun* – a hill – and *Ley* – a Scandinavian name for a town or settlement. It was referred to as Donsley in a 1396 abbey charter and is situated close to Sandsend Bay, which was mentioned by Ptolomy as *Dunus Sinus*. Both the Romans and the Vikings (AD 867) are said to have used the gently sloping beach to land their boats in the bay. Nearby Raven Hill is said to be where the Viking flag showing a raven was placed. A plaque with a Roman inscription was dug up at Dunsley in 1774, marking the site of a fort built by Justian.

DUNSLEY CHAPEL

Dunsley's Church of England chapel (now a dwelling) is situated in the centre of the village having previously been the village school and later used as an extension of Aislaby church. It is said that the original chapel was built at the same time and to the same design as similar ones in Ugglebarnby and Aislaby, having been older than the old Hermitage at Mulgrave. The foundations of the original Dunsley chapel, to the rear of the present building, are not detectable, but were quite visible in 1816 when an engraved stone could be seen with the inscription: 'Lord have mercy on ye soul of Ed ...' The foundations of this building are recorded as measuring 30 feet by 24 feet with a chancel of 16 feet. There was also a surrounding cemetery from which bones were unearthed when materials were taken from the mound for road works in 1814. A local farmer, the late Mr Arthur Hodgson of Moor Leas Farm, Dunsley, recalled that as a child he had regularly joined with other children in digging for bones from the graves; the gravestones from these graves are said to have been used to cover the culvert near the former old blacksmith's. The mound in the centre of the village was superficially excavated by amateurs in the 1800s, but only in search of valuable objects. In modern times, a piece of old leaded-glass window was found close to the surface by use of a metal detector which gave readings over a large area, possibly from the existence

of lead coffins or roofing materials buried below. The open and easily accessible site is ideal for a modern, professional, archaeological dig.

DRY DOCKS & DOCKS

A number of docks were built on the sand or mud between Dock End and Bog Hall in Whitby's shipbuilding heyday. On the east side of the Esk substantial twin dry docks were constructed just north of the foot of Green Lane. In recent years, during the works to provide a new sewer system to the town, an old dry dock was rediscovered under the car park abutting the corner of Church Street and Grape Lane. In 1734, Whitby's east side dry docks were listed as belonging (separately) to Messrs Barker, Holt, Reynolds and Watson. Those on the west side were built at a later date and included Fishburn Docks (built 1757), Sympson's (1759/60) and another owned by Jarvis Coates at Bagdale Beck.

EBENEZER CHAPEL / WESLEY'S MEETING ROOM

This was an octagonal building situated on Haggerlythe that was used by Wesley on his visits to Whitby to preach Methodism. It fell into the sea and was replaced in 1788 by a new chapel in Church Street. Wesley is said to have been impressed by Whitby people who were tolerant of his new ideas, unlike some areas where he was pelted with missiles. He described Whitby women as being 'well dressed without being overly showy'. The meeting room, topped architecturally by a round ball, can be seen on some of the older engravings showing the eastern side of the harbour. The name Ebenezer in biblical terms means 'stone of help'.

EGTON = EGGERTON = ECHTON = OCHETON

Egton appears in a variety of spellings with its name having nothing to do with eggs, but instead meaning Oak Town.

EGTON FAIR = PALMSON FAIR

There were originally four fairs held annually at Egton in the 1800s, namely on the Tuesday before May Day (1 May), on St Bartholomew's Day (24 August), on the Tuesday before St Martin's Day (11 November) and on the Tuesday before the purification 'old style' (meaning the old feast day of Lupercalia, 15 February – the feast of purification new style is 2 February). One of these fairs was called St Hilda's Fair.

Another source tells us that anciently the four fairs were granted (or re-granted) by William III to Henry Viscount Longvilliers to take place

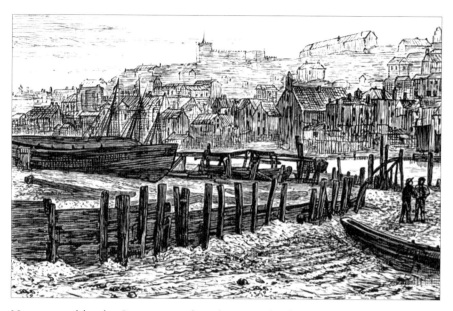

Now covered by the Co-op car park and marina development, the western bank of
the Esk was Whitby's thriving shipbuilding area.

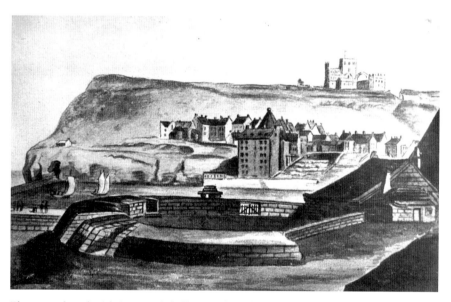

Ebenezer chapel with its round, ball-topped roof (centre), which fell onto the harbour
during one of the numerous cliff falls in this area.

on the Tuesday before Palm Sunday ('Palmson Fair'), the Tuesday before Quinquatrus (13 May), the Tuesday before St Cuthbert's Day (4 September) and the Tuesday before the feast of St Clement (23 November). By 1827, the 'Palmson Fair' was chiefly a cattle market and there were only three annual fairs, the other two being on May Day and in October.

ESKDALESIDE (modern) = ESCHDALSYDE = ESTILL SIDE

This is the well-known road running along the Esk valley from Sleights to Grosmont.

ESKDALE CHAPEL

Situated near Sleights, this chapel was still in existence in the 1700s on a site close to the modern railway line, just beyond the main bridge over the river. It is believed to be the chapel mentioned in the Penny Hedge or Horngarth Ceremony legend. A small priory stood here in the reign of King John.

ESK HOUSE

This was a former private school in a substantial house overlooking the harbour and River Esk, near to the present police station. It was badly damaged by bombing in the Second World War and was replaced by the terraced row of houses now to be seen on Windsor Terrace.

ESTBEK

Estbek was named by Leland as the river running out of East Row, Sandsend. The word *est* signifies east and *beck* is a local name for a small river.

FACTORY FIELDS

The fields stretch almost from Chubb Hill to the Switchbacks and Four Lane Ends, and take their name from the former sail-cloth manufacturer on the site of Beavers carpet warehouse. A well was once situated close to the metal gates at the Chubb Hill entrance. The footpath follows the route of Whitby's main 'post road' in the days when mail was carried by horseback.

FAIR ISLE

The few cobbles that remain near the bus stop in the Potato Market are part of a once much wider area in Church Street called Fair Aisle, where fairs would be set up during festivities.

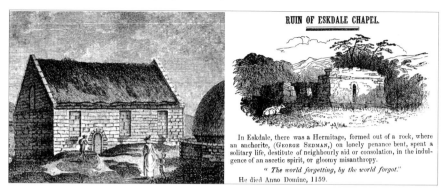

RUIN OF ESKDALE CHAPEL.

In Eskdale, there was a Hermitage, formed out of a rock, where an anchorite, (GEORGE SEDMAN,) on lonely penance bent, spent a solitary life, destitute of neighbourly aid or consolation, in the indulgence of an ascetic spirit, or gloomy misanthropy.

" *The world forgetting, by the world forgot.*"

He died Anno Domine, 1159.

Two old views of the thatched Eskdale chapel showing it as it was when in use and in ruins.

Luckily for posterity, Esk House (centre right) and some now vanished shipyard buildings were captured forever on this rare Victorian lantern slide.

FAIRMEAD

A former house and grounds of substantial size situated on Larpool Lane. It later became the Talbot Hotel and public house. The building was demolished to make way for modern housing development.

FARNDALE FIELDS = RUSSEL LANDS

The fields upon which the West Cliff Estate was built are full of natural springs which conveniently provided the water for the Victorian development of the area. One explanation of the name is that the damp soils encouraged a display of wild daffodils equalling that of Farndale; although like many place names in Whitby the fields may have retained the surname of a previous owner. The Skinner Street area was bought by William and John Skinner from Thomas Hay in 1762, and they erected a tile works at its northern end in that year.

FEATHERBED LANE = STRAIGHT LANE

Featherbed Lane is often confused with the road that passes up through Woodlands to Aislaby at the end of Briggswath, though the true Featherbed Lane is accessed by some easily missed steps near the entrance to Woodlands. The path (once a road) climbs steeply up the bank towards Aislaby and affords magnificent views across the valley. It takes its name from the softness of travel afforded by piles of fallen leaves.

FIELD HOUSE

Said to be the second best stone-built house in Whitby in 1817. It was built by John Addison and was once the seat of Christopher Richardson Esquire. Field House stood in a field almost opposite the Upgang Lane entrance to Tucker's Field. It was demolished in the 1960s.

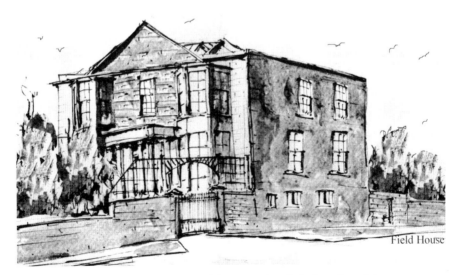

Field House

A sketch of the building known as Field House, shortly before demolition.

FIELING = FYELING = FIELDING = FYLING

The former name of Robin Hood's Bay area mentioned in old abbey charters. There is some confusion over exactly which parts of Robin Hood's Bay had this name due to divisions such as Fyling, South Fyling and 'the other Fyling' occurring in old documents. The name is said to mean a *thirding* – a division of the greater area of Fylingdales that stretches across the moors towards the main Sleights to Pickering moor road. Other historians link the name to the *Fyerding* Anglo-Saxon military force.

FISCHERGATE

In 1221, a Whitby deed shows that half a toft was held here by William Cordarius, son of Laising. Fischergate appears from the text to be in Whitby, but may actually refer to Fishergate in York. It could also be an earlier name for Fish Ghaut (see below).

FISH GHAUT = FISHGHAT = FISH GOAT

The word 'ghaut' is a local one meaning a sloping slipway or steps leading to the harbour. Fish Ghaut was the extension of Ellerby Lane leading to the stepping stones or footbridge that crossed the river in earlier times. A bricked-up stone wall on Sandgate still marks the point where it entered a tunnel to the harbour. Similarly, the arch of the bricked-up tunnel is also visible from the western side of the river. Fish Ghaut was a fish market in the early 1800s and is believed to have been part of the main ancient thoroughfare from Flowergate Cross to the abbey. The route from Flowergate went to St Anne's Lane (formerly Hell Lane), and then by ford, stepping stones, ferry or bridge across the harbour, up Ellerby Lane, through White Horse Yard and Black Horse Yard, which were once linked, and continuing up the hillside to the abbey.

FISH MARKET

The town's fish market was originally held on Staithside, part of what is now St Anne's Staith. Other fish markets have been held at various times in the old market place on the west side of the Esk, at Fish Ghaut (early 1800s), on the Fish Pier, at Coffee House End and, in the late 1800s, on the wooden quay (now New Quay Road). In effect, the fish market traded wherever fish were landed. It is clear that fish were not sold in the normal market which traded each Saturday. Interestingly, in the early 1800s only nine fishermen fished out of Whitby, most of the fishing trade being carried out at coastal villages.

The fire at Saltersgate Inn was said to have burned for hundreds of years without ever being extinguished.

FISH ROAD = SALT ROAD

This was one of the earliest recorded roads across the moor from Whitby to Pickering and beyond. The inn at Saltersgate Bank (now renamed Saltergate on local authority signs) was used for the transportation of fish and sea salt made at the Saltwick salt pans. The Saltersgate Inn once had a fire that was said to have burned continuously for hundreds of years. Priest holes, used for hiding Roman Catholic priests on their journey across Britain during the days when 'Popery' was banned, were commonly accessed from fireplaces, and it is thought the original, legendary fireplace may once have literally been a 'smoke screen', hiding a concealed access to a secret upstairs room.

FITZ (1778) = THE BATTS

An area close to the harbour between Whitby and Ruswarp, giving its name to Fitz Steps on the Mayfield Road to Ruswarp footpath. The Batts takes its name from Batts Foundry, which once occupied part of the area. The origins of the steps' name 'Fitz' – meaning 'son of' – have been lost to history.

FLEMESBURGH

Though some historians say this refers to Flamborough, some have identified it as the lands of Tancred the Fleming in Fyling, Robin Hood's Bay.

FLOWERGATE = FLORE (1086) = FLORE GATE = FLOREGATE (1290s) = FLORUN = FLORA = HIGH STREET (1700) = NEW BUILDINGS (1700)

Flowergate is one of the oldest thoroughfares in the town, possibly being the main road to the abbey from the direction of Sandsend. A number of records have been preserved of early owners of lands in the area. Whether the name reflects a floral connection or a Roman one (*Flore* indicating a pavement or lane) is uncertain, though it is certain that Florun or Flore was at one time a recognised village or hamlet. Thomas de Hotton and Thomas de Bermingham are both listed as holding lands at Flore in around 1290. Thomas bought half a toft between the lands of Bartholomew, son of Alexander, on the east side of Flore and those of Ralph the fisherman on the west side. Geoffrey, son of Thomas of York, held one toft of land there also in 1290. That toft had previously been held by Matilda de Camera and Ralph de Hotton. It is also recorded that another resident, Simon Porter of Whitby, bought a house here next to Alexander the weaver in the same year and that Alexander's house was situated next to the house of William, son of Petronilla. Again in 1290, Hugh, son of Roger Prudom, bought land from Walter, son of Godefrid and grandson of Blaker, consisting of one toft between the land of Richard Freeboys and Agnes, wife of Thomas Cook.

It is also known that Thomas Skyn, son of Richard Skyn, granted the Abbot of Whitby Abbey half a toft between the lands of Walter, son of William the Fuller, and those of Isabel Fox in Flore, in 1292. Later in 1313, the same toft was described as being in Floregate and had been let by the Abbot Thomas to Richard Landmote. It was then described as being between the two tofts of William de la Sale. Other places that skirted Flowergate but are now gone were Tenter Close (part of the Paddock), Bakehouse Garth, Correction House Garth and Marsingale Closes.

Flowergate was levelled and widened in 1750, so the steady slope we see today bears no relationship to its original hilly state, which included a deep hollow that was levelled out in order to make a turnpike road.

The modern buildings on St Hilda's Terrace on the northern side of Flowergate were originally called New Buildings. A later attempt to call the back of St Hilda's Terrace King Street either never caught on or was forgotten when St Hilda's iron church was moved to the plot at the top of the street. The plot has been built upon except for the large grass square on the bend in Crescent Avenue.

Number 1 Flowergate (now the Sutcliffe Gallery) housed one of the town's least-recorded public houses. In the *Whitby Gazette* of 11 February 1898 we are told:

The building, No. 1. Flowergate, recently occupied by Mrs Berry as a game shop, has seen many changes since it originally bore the peaceful title of the Olive Tree Inn. Now it is undergoing another transmogrification, and will be opened in a few weeks time ... to the order of Mr. Thomas Bland, by an enterprising Antipodean, as a music warehouse.

FLOWERGATE CROSS = FLORE GATE CROSS

As Flore was listed as a separate village in former times (1086), it is likely that an actual market cross existed here. A cross is certainly marked on old maps in the vicinity of what is now the roadway roundabout. A number of ornate stone heads, which may have come from a covered market cross, were discovered in the former gardens of what is now the Conservative Club. They are now to be seen in Whitby Museum.

FLOWERGATE LANE

Flowergate Lane was part of Flowergate, but extended only from Flowergate Cross to the top of what is now Brunswick Street. From that point downwards was a continuation of Skate Lane (Brunswick Street) leading to Cliff Street. The remainder was probably part of Primrose Bank, a name given to the bank on which the former Woolworths store was built at the bottom eastern end of the street.

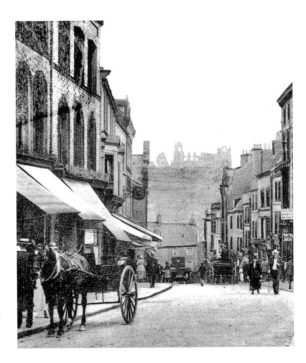

Flowergate Lane ended near the Little Angel Inn and descended to Primrose Bank at the foot of the present Flowergate.

FORNELEGE

Grose's *Antiquities of England and Wales* mentions it as one of the villages near Whitby that is noted in early abbey deeds. The only local names that correspond in any slight way are 'Thorney Brow' and 'Thornelay'. If we examine the usual Scandinavian connections to names in the area we find that Forne means ancient or former in Swedish, while Lege translates as games in Danish.

GALLOWS CLOSE = GALLUS CLOSE = CALLER FIELDS

Before the mid-1960s, the name was in common usage but is being used less and less by modern generations. The name refers to the Helredale area, particularly the part just above Spital Bridge, to the left when leaving town. A gallows is said to have stood here until the 1700s. The last recorded hanging was in 1660, when two local men, one called Lumley, were executed. A popular pub song about the hanging was said to have been sung in local hostelries but appears to be now lost. In later years, particularly through the 1950s, the fields above Spital Beck, also known as California Beck, were known as Caller Fields or the Yorkshire Penny Bumps, a well-used sledging area in the more common snowy winters. Also in the 1950s, children's swings stood on the corner of the field, immediately above the top end of Spital Bridge. Later, public toilets were built on this same corner before they too were demolished. Local people refer to the area as Gallus

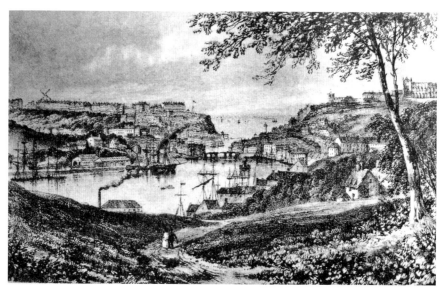

Gallows Close as it was in the 1800s. It is interesting to see that the artist has omitted the West Pier from the engraving.

Close, a name which may have even more ancient connections to the abbey, as *gallus* was the Latin name for a cockerel. One speculative possibility is that a chicken farm attached to the abbey was once situated in this same area, possibly on the site where a farm existed in relatively modern times.

GASWORKS

Staffordshire Place, Flowergate (opposite the Little Angel public house) was the home of Whitby's first municipal gas suppliers; though even before that, whale oil was used to light Whitby's streets long before many cities had adequate municipal street lighting. Another early gasworks was situated at the bottom of Church Street. The old Gas House (residence) still exists and the circular gasometer enclosure is now part of the motor tyre suppliers close to the Horse Road. Pedestrians climbing the Horse Road can still look down on the circular enclosure cut out of the stonework. The first full-scale lighting of the town by gaslight took place on 11 November (some records state December) 1825, the same day that the Pier Museum, library and public baths were opened in what later became Simpson's Café. A foundation stone for the baths and other facilities was laid by Colonel Wilson of Sneaton Castle. In a cavity within its structure were placed coins,

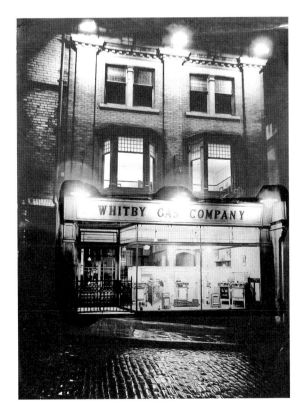

Now a charity shop, this building was once the Flowergate headquarters of the Whitby Gas Company.

a copy of the *Whitby Repository* newspaper, a Yorkshire newspaper and some glass engraved by Doctor Ripley. A meal for dignitaries was held that evening at the Angel Hotel in celebration of the town improvements. In historic terms, Whitby was quite advanced in its municipal facilities. Streets in the town were paved in 1764, and street cleaners, known as 'Scavengers', were employed to keep them clean. The most modern of Whitby's gasworks is now gone, but was situated almost directly underneath the viaduct which carried the former Whitby to Scarborough railway line.

GHAUT = GAT = GOAT

Though pronounced Goat in local dialect, the misspelling of the name is only carried out by non-residents, usually on postcards and in books. There are now fewer ghauts in Whitby than in the past, though a number remain. All are narrow, sloping alleyways leading down to the water's edge. That name is believed to derive from the Scandinavian *gat*, meaning a way through. Interestingly no other places in England seem to use the word, though it is common in India.

FISH GHAUT: (See under its own entry.)
HILDRITH'S GHAUT (1828): It was situated below Henrietta Street, north of Tate Hill and was named after St Hilda.
HORSE MILL GHAUT (1817): (See under BAGDALE 'OLD' HALL.)
LANDRY GHAUT (1775 and 1828): Landry Ghaut (Laundry Ghaut) was located beyond Hildrith's Ghaut.
NEW WAY GHAUT: (See under its own entry.)
PONT GHAUT: Charlton, in his *History of Whitby*, tells us that this was the former name of Fish Ghaut.
TIN GHAUT: The name causes confusion because two ghauts at opposite ends of Grape Lane had the same name at different times. The first was alongside the Raffled Anchor Inn at the bridge end. When the pub was demolished, the name was adopted by Rippons Ghaut near the Britannia Inn at the Church Street end. The reason for this is that the name simply meant 't'inn ghaut' (the ghaut near the inn).

GLEN ESK

A name now rarely used except by older residents. Glen Esk is the riverside glen situated at the bottom of Danger Bank, on the Larpool Lane route to Ruswarp. Given that this is near the shallowest part of the River Esk, it is highly likely that a ford crossed the river here. The existence of small, well-built stone bridge, hidden away and now leading nowhere (on the opposite side of the river) also gives credence to this theory.

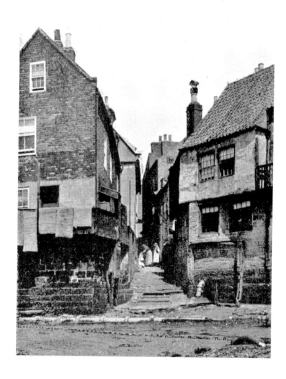

Tin Ghaut, as it appeared from the harbour around 1900.

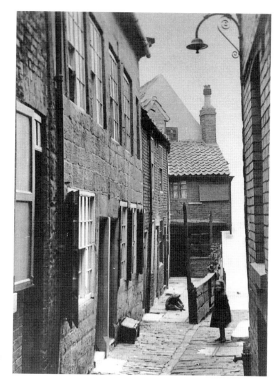

Another view of Tin Ghaut, this time viewed from Grape Lane.

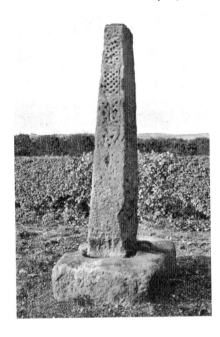

Situated in a country garden at Hawsker, the oldest carved cross in the neighbourhood is barely noticed by passersby.

GNIP (*c.* 1100) = HAUSGARTH = HAWKSGARTH = HAWSGARTH = HOUSEGARTH = HAW SCAR = HAWSKER = HIGH & LOW HAWSKER

Hawsker was settled in Anglo-Saxon times and the name Gnip (*Knip* = to cut) appears to be from this time. The village contains the remains of one of the oldest Anglo-Saxon crosses in the neighbourhood. It stands unprotected in the middle of a small, fenced-off patch of garden, which formed part of the grounds of a now vanished chapel dedicated to All-Saints. The name Hawsker in various forms has been explained in various ways, the most commonly accepted being that it is derived from a former hawk training area. In 1824, Hawsker had a population of 724, including a 'House of industry for the poor'.

GODELAND = GOTLAND = GOTELAND = GOATLAND = GOATHLAND

The modern village of Goathland, better known to many as Aidensfield in the *Heartbeat* television series, is believed to have been named by Viking settlers from the Scandinavian island of Gotland, which has as its capital Visby (formerly Wisby).

GOLDEN GROVE

The woods beyond Larpool have had this name at least since the Middle Ages. Records reveal that there was a 'Gold Mill' in the woods, though

this has been interpreted as a mistranslation of the mill's name in Latin. Rigg Mill was said to be erected here, in place of a former corn mill, by Alexander de Percy, abbot of Whitby (1315). A strong possibility is that the abbey used the older mill for working metals, including gold or coin-making, though it is unlikely that the stream yielded gold as some have speculated.

GOLDEN LION BANK

This ancient thoroughfare takes its name from the sign of the Golden Lion public house at the foot of the bank. In 1714, the pub, which at one time was the home of the Lion Lodge of Freemasons, had a large golden lion figure erected on a post. The present building appears to be much smaller than in earlier days when it boasted commodious dining rooms. Golden Lion Bank was, until the early 1960s, still used as a road on rare occasions when vehicles would take a shortcut from Flowergate to the Bridge End and vice versa.

GOLDSBURC (*c.* 1200) = GOLDSBOROUGH

Goldsborough was the site of a Roman military camp, and possibly one of the terminals of the Roman road of which remnants still exist on Wheeldale Moor. The road has been traced as far as Aislaby, with a ridge stretching out from there towards the village of Dunsley. The name appears to be a quite literal variation of Gold's Borough.

GRANDIMONT = GROSMONT

The modern village of Grosmont grew from an older settlement that was built up around a priory that housed monks from Grandimont monastery

Few visitors to the steam-train attractions today would believe that Grosmont was once an industrial area. This engraving shows some former lime kilns.

Golden Grove Woods and the surrounding area are criss-crossed with ancient 'pannier-man' tracks such as this one.

The Golden Lion public house is believed to have medieval origins. Its two rooms are depicted here as they were in the 1960s.

in France. The priory was 100 feet by 40 feet, with cloisters 100 feet away near the river. The name 'Grandi Mont' or 'Gros Mont' means large mound. In the 1800s, the village was a hive of industry with lime kilns and iron works.

GREEN ISLAND

This little island in the harbour close to Church Street and Alders Waste was probably formed from years of accumulated waste which had been cleared from the watercourse. Interestingly Cholmley, the former lord of the manor, was once fined for not clearing out the waste. It would seem that another island of mud, further to the centre of the harbour (Bell Island?), was also called this during the summer months when either grass or green algae covered it at low water.

GREEN LANE

Green Lane was literally once a green grassy lane that existed close to its present course but behind the old Hoggarth's building and the Bottom House pub (formerly the Golden Fleece). The road joined up with both the ford across the harbour and the road over the old, smaller Spital Bridge.

GREFFER LANE = GREFFER GATE = GRIFFIN LANE?

According to Holt (*Whitby Past and Present*, page 29) it was an old name for Sandgate. It may have originally been Griffin Lane, derived from the griffin on the Cholmley family arms that is retained in the name of the White Horse & Griffin on Church Street.

GROPE LANE (1638) = GRAPE LANE = LOMBARD STREET (colloquial)

The original name, Grope Lane, may only have been colloquial. Many towns have a Grape or Grope Lane, said to have been extremely narrow and dark. In most cases they had a vulgar expression attached to the word Grope. The name Lombard Street referred to the banking activities that took place there, which began in the Old Whitby Bank in the building occupied by Whitby Archives until the end of the year 2000. It had a green gate at its entrance and was called the Green Gate Bank locally, being the first local bank to issue banknotes in place of bills of exchange. The building next door at No. 19 was a solicitor's office and may have been physically connected by an adjoining door. The name Greengates was transferred next door to No. 19 by a purchaser of the building in the 1960s, who, on finding the old solicitor's safe, assumed it to be the

bank vault. Grape Lane and Sandgate were once collectively known as the Low Streets.

HAG

A hag is a piece of rough ground. The word is a constituent part of a number of Whitby Place names.

HAGG

Described in a Victorian directory as being 2¼ miles 'SSW of Whitby', this was probably the land around Haggit Howe, also known as High Gate House and Hagit Hou. This was originally a house built near the gate to High Felde, possibly used as a gatehouse to the abbey lands.

HAGGERLYTHE = HAGGLATHE (1761 and c. 1800) = HAGGERLATHE (c. 1820) = UNDERCLIFF

The name is taken from 'Hag', meaning rough ground, and 'Lythe', meaning sloping meadowlands. Haggerlythe is the extension of Henrietta Street towards the cliff edge. The name probably indicates the area was used as grazing land in ancient times just like the 'Undercliff', which appears to have extended from Haggerlythe along the seaward side of the cliff. This area, which has long since fallen into the sea, was also used for fairs and local gatherings. Henrietta Street got its name in 1761, when it was named after the wife of Nathaniel Cholmley, lord of the manor. Two roads originally stretched alongside this part of the cliff, but were reduced to one following a number of landslips. The worst of these took place in 1787, when a gun battery fell into the sea and a number of dwellings were lost. Other major landslips occurred in 1870 and 1932.

HAGGERLYTHE ROAD = CHOLMLEY ROAD

This steep road, constructed by Lord Cholmley's workers, led from Abbey House (or Whitby Hall as it was then named) across the Abbey Plain and continued down the side of the East Cliff to the East Pier.

HAGGERSGATE = HAGGAS GATE = HAKELSOUGATE (1290–1300) = HAGGLESYGATE (1600) = HAGGIS GATE (1660s) = HAGGLESEY STREET (1644) = HAGGILSYKE = HACKERSGATE (c. 1800)

It is likely that both Haggersgate and Haggerlythe took their names from pieces of rough land. However, it is interesting to note that John

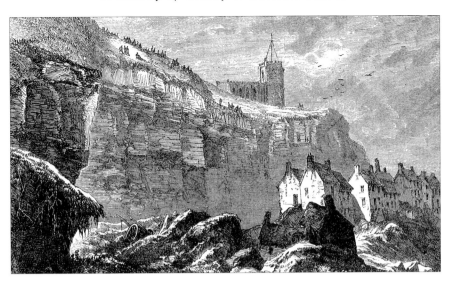

Devastation at Haggerlythe and Henrietta Street in the 1800s, after one of the frequent landslips.

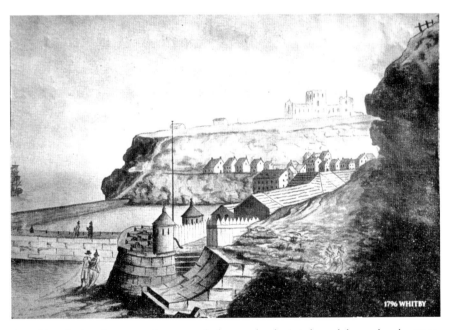

An old painting from 1796 captured the rarely depicted, and hazardously steep, Cholmley Road that linked the cliff top to the East Pier.

Haggas, a stonemason, died in Haggersgate in 1637. Much earlier, around 1290, Hugh, son of Alexander Suanball, rented 'a shop and soller in Hackelsougate towards the street'. The word 'soller' is probably a misspelling of the word *sollar* – a loft or garret.

'HAGGERSGATE HOUSE'

Once inhabited by the Yeoman family in 1817, it was the home of Richard Rudyard, a relative of Rudyard Kipling. The building was opened as a seamen's mission in 1877 by Rector Austen. It is recorded that the artist W. Lawson decoratively painted the chapel within the mission.

HALL'S YARD

The name dates back to at least 1686, when Whitby's town surgeon, Mr Gibson Hall, lived in Hall's Yard, situated behind the former Duck's draper's shop in Flowergate. His son, Mr George Hall, was a draper's apprentice at Clarkson's draper's (Bridge End) with David James Waller, who later became president of the Wesleyan Methodist Conference. George Hall, who later went to live in Newcastle, used to recount that he was carried up the 199 steps to be christened and that he later attended Blacklock's school. He remembered being able to fish from Mr Blacklock's bedroom window. Mr Hall's sister was wife of Mr Tom Bradley, who had a tobacconist and newsagent's shop on St Anne's Staithe. His mother, the wife of Gibson Hall, was the first woman in Whitby to have an oven installed in her house. Visitors would come from far and near to see the latest wonder. Mr Gibson Hall's father, George's grandfather, was famous as the inventor of the swivel mechanism for harpoon guns. It made life much easier in the days of Greenland whaling. This particular Mr Hall was a smith by trade and his invention won him a cash award when it was presented to the Royal Society. With this prize money he purchased a mahogany grandfather clock which played a different tune every day and showed the position of the sun, moon and tides. It is recalled by the Hall family that Whitby ship owners lived and worked unpretentiously. One, who had a tailor's shop, lived in a yard and kept his ships' papers in boxes under the shop ceiling. While he toiled at home sewing garments, his ships worked for him at sea.

HAMESSOM

According to *Antiquities of England and Wales* by Grose, a medieval deed of William de Percy curiously mentions the 'Seaport of Whitby and Hamessom'. There appears to be no record of where Hamessom was,

though the context seems to indicate that it was a town of substantial size, that was either part of the Whitby community or alternatively used Whitby as its port. It is possible that Whitby occupied the eastern part of the Esk, while Hamessom occupied the west bank. The only similar names that can be found locally are Hammelrigs (see page 149 of Charlton's *History of Whitby*) and less likely, the towns of Hamar in Norway, and Hammarstrand in Sweden. Interestingly, given Whitby's Viking past, the words *hjem somm* mean 'summer home' in Old Norwegian.

HAPPY VALLEY

This narrow valley, now fitted with steps, allows access from the cliff top to the beach close to the White House Hotel near Upgang. Whitby's outdoor swimming pool was once located at the top of the steps. The origin of the name Happy Valley is said to be derived from a nickname given to the relatively wealthy residents who built the houses on the cliffs here. The original 'Happy Valley Set' was an elite social group of privileged British colonials who lived in the Happy Valley region of Kenya in the 1920s and who came to public notice due to their hedonistic behaviour.

HARKER'S BUILDINGS

This was a group of buildings on the Crag that was demolished in 1957. The buildings were owned by the Harker family, who were jet and coal merchants with a coal warehouse at Alder's Waste Ghaut. The Crag buildings were once well-kept dwellings, but by the 1900s they had deteriorated, many having become warehouses.

HARLAND'S PIPE FACTORY

Harland's factory occupied the last building along Haggerlythe. It fell into the sea in 1870 during one of Henrietta Street's landslips, but can be seen on some old pictures of the east side of the town. It appears to have manufactured clay pipes for smoking rather than terracotta drainpipes.

HAYTERSBANK FARM

It was renamed 'Sylvia's Cottage' after 1895, when it was featured in Linskill's novel *Sylvia's Lovers*.

The now demolished Harker's Buildings as they were in the early 1900s, when they were used as warehouses.

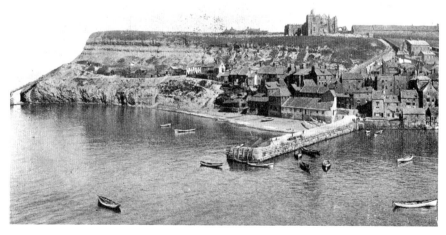

In 1870, Henrietta Street suffered another cliff fall. Harland's pipe factory and some of the other buildings seen here fell into the harbour.

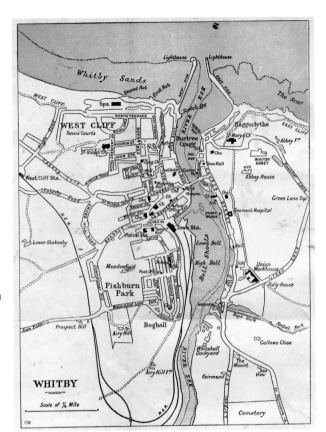

Right: 1. In 1913, Whitby maps still showed names no longer found on modern maps, including Burtree Cragg, the Workhouse, West Cliff Station and the Spital Beck Rope Walk.

Below: 2. In 1855, the 'Whitby road' from Sandsend to Whitby ran along the beach.

3. In the early 1900s, an amateur artist accurately captured this view of the buildings along the eastern harbour side from Whitby Bridge to the Board School.

4. In Whitby, prior to 1910, the pier had no extensions, and bathing machines were parked near the circular buildings once used to store gunpowder for the nearby coastguard station.

5. Sandgate was known as the Shambles in the 1800s, when it was full of butcher's shops. This 1882 bill for twelve dozen candles at a cost of £3 was signed by one of these butchers, Joseph Wilkinson, who was also a chandler.

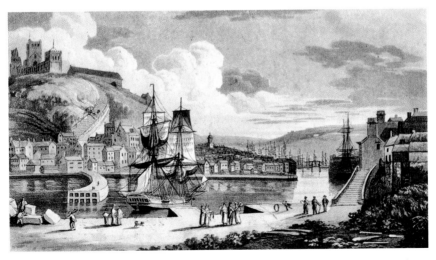

6. In the 1700s, Pier Road had not yet been constructed. Access to the town from Scotch Head was via a set of steep steps leading to the Crag.

7. Spring Vale (looking towards town) is depicted in this early sketch as virtually a country lane. Today, modern bungalows have replaced the fields and woodland.

8. Links Cottage (now demolished) stood on the corner of the golf course, near the junction of Sandsend Road and Love Lane. The White House Hotel and the sea can be seen behind it.

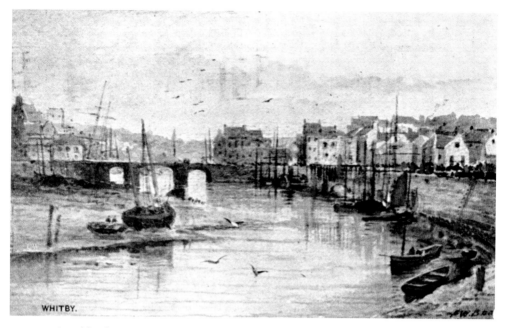

WHITBY.

9. An old colour postcard illustrates the harbour as it looked in the days of the old swing bridge. Conspicuous are the sloping walls of the old Pier Road and the Boots Corner buildings.

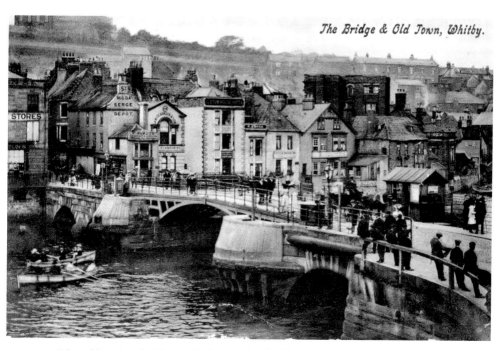

The Bridge & Old Town, Whitby.

10. The old swing bridge and the nearby buildings, including St Hilda Serge Depot, Sawdons, Clarkson's Furnishers, the Custom House and the Raffled Anchor, are captured evocatively by this fascinating and old colour postcard.

11. Whitby's West Cliff is depicted here as it was *c.* 1900. It is interesting to note the former West Pier Sands, Union Mill (top left), and the Victorian bathing machines at the foot of Khyber Pass.

12. In 1837, Francis Pickernell was responsible for all work on Whitby piers. This rare order signed by him includes treenails, oakum, tar, deck nails and a gallon of whale oil.

Right: 13. The name of Argument's Yard continues to fascinate visitors to this day, as it did when this postcard was issued in 1913. The name has nothing to do with quarrels, but derives from Mr Argument, a former resident.

Below: 14. Runswick Bay has suffered from cliff falls over many years, changing the layout of the village and its access routes from the cliff top. This view dates from 1912.

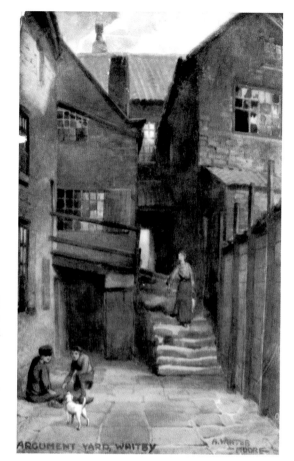

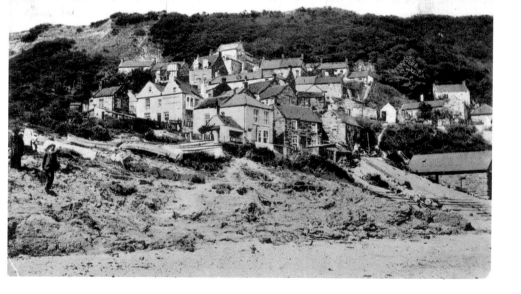

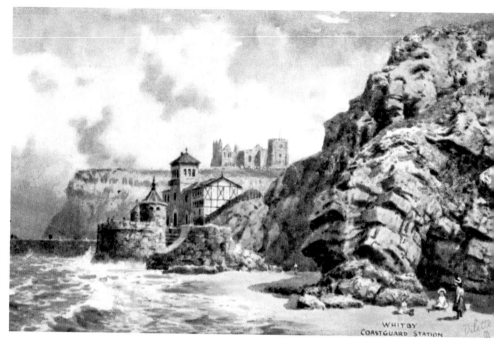

15. The old coastguard station on Battery Parade is now occupied by café premises. The two round buildings, which used to store explosives and equipment, are still in existence.

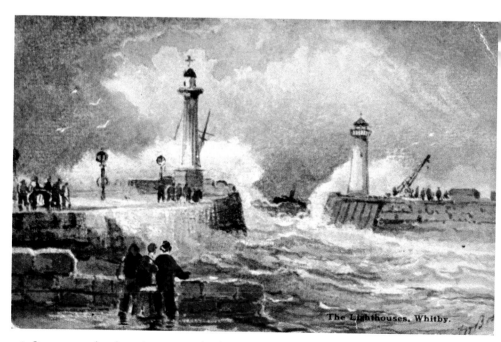

The Lighthouses, Whitby.

16. Stormy weather has always posed a hazard to ships entering the harbour, as shown here in 1908 as people gather on the sea-washed piers to observe and assist.

Right: 17. When this old postcard was printed in the early 1900s, donkey traffic still used the Loaning (now known as the Donkey Road) next to the 199 steps. This view shows a donkey, with a child on its back, climbing the steep road.

Below: 18. Scotch Head as it appeared in *Punch* magazine in 1889. The popular cartoon featured the child of a visitor, 'Sir Pompey', asking permission from her governess to join the rough and ready children who regularly played there.

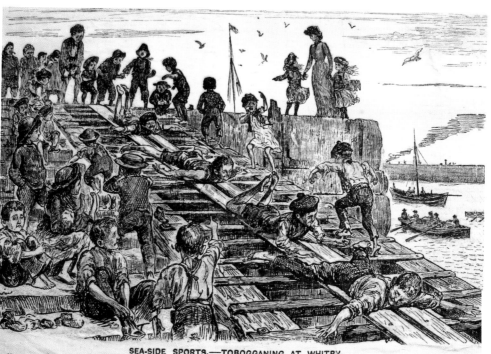

SEA-SIDE SPORTS.—TOBOGGANING AT WHITBY.

Miss Eva Bedell. "OH! DO LOOK AT WHAT A LOVELY GAME THOSE DEAR LITTLE BOYS ARE PLAYING AT, MISS SMART! MIGHTN'T ME AND MAUD PLAY AT IT TOO!"
The New Governess. "CERTAINLY NOT, EVA. I FEEL SURE SIR POMPEY WOULD CONSIDER SUCH A PROCEEDING MOST UNLADYLIKE!"

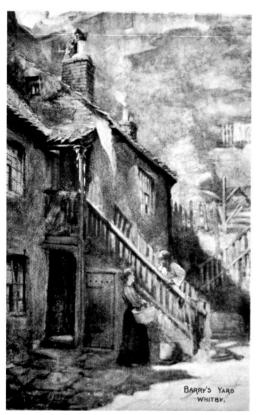

19. Numerous yards and tenements such as Barry's Yard have vanished from the Cragg since the early 1900s. Though picturesque, they were in many cases run down and without any conveniences.

20. This rare wage bill, signed by Francis Pickernell, lists a number of men who were engaged in working on the piers in 1837. Many surnames are still prominent in the town, including Weatherill, Lawson, Simpson and Lyth.

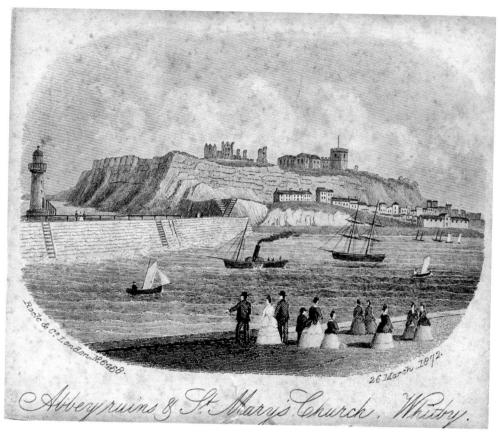

Abbey ruins & St. Mary's Church, Whitby.

21. A miniature engraving produced in 1872 shows the East Cliff following previous cliff falls. Unusually, two Spa Ladders can be seen joining Haggerlythe to the East Pier.

22. The Mulgrave Castle Inn was a pub popular with both locals and smugglers before it fell into the sea at Upgang in 1887. Two years earlier, its last landlord, Francis Cornforth, moved to the Beehive at Newholm.

ORDER OF PROCESSION

ON THE OCCASION OF

OPENING
THE NEW
BRIDGE
AT WHITBY,
On Friday, 27th of March, 1835.

Flag—Union Jack
The Workmen two and two
The Clerk of the Works
The Bridge Master of the Riding
The Harbour Engineer
The Contractors
The Band
Flag—Whitby Arms
The Magistrates
The Commissioners of the Piers
The Bridge Committee
Flag—Ensign
The Gentlemen of the Town
Private Carriages
Gentlemen on horseback
Public Carriages

The Procession to form in Bagdale, at One o'Clock, and to move from thence along Baxtergate to the Bridge; on arriving there, the head of the Procession, and the Magistrates and Commissioners of the Piers, are to pass along to the East Side, whilst the rest of the Procession will remain on the West Side until the Bridge has been opened, and a Ship has passed through, decorated with colours, and having a Band of Music on board. When this part of the ceremony is over, and the Bridge closed again, the Procession to pass along Bridge-Street and Church-Street, as far as the Green Lane, and then return in the same order to the Old Market Place, where it is to disperse, the Band filing off, on one side, and playing "God save the King,"—"Rule Britannia,"—and other popular Airs.

The Committee respectfully request Gentlemen to allow their carriages to attend the Procession.

Committee Room, March 25, 1835.

23. On Friday 27 March 1835, the then new (not the present) bridge over the River Esk was opened amid public rejoicing and a procession of dignitaries through the town.

24. Robin Hood's Bay is said to have taken its name from a real-life character who kept a fleet of boats here. The village, known also as Baytown, has long been regarded as a haven for smugglers.

THE PROMENADE SANDSEND
FROM SANDSEND HOTEL

Above: 25. Sandsend, meaning literally the end of the sands, was reputedly a regular landing place for both Roman and Viking fleets. The cliffs near Kettleness Nab were once the centre of the local alum industry.

Right: 26. Tate Hill Pier takes its name from Tate Hill, now no more than a footpath leading to the pier. It was once a busy thoroughfare used by horse- and donkey-drawn vehicles.

27. An early 1900s postcard of the east side and Haggerlythe shows the extension of Henrietta Street before erosion reduced it to its present state.

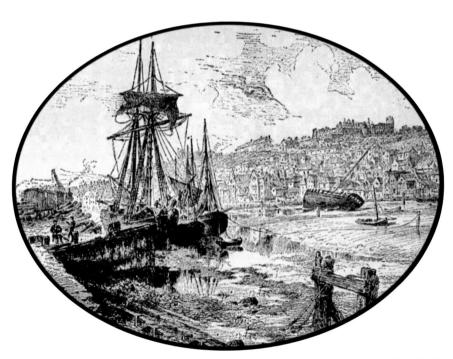

28. In the late 1800s, when this picture was drawn, the shipyards that built Captain Cook's ships were falling into decay. The area is now covered by the Co-op supermarket and the marina development.

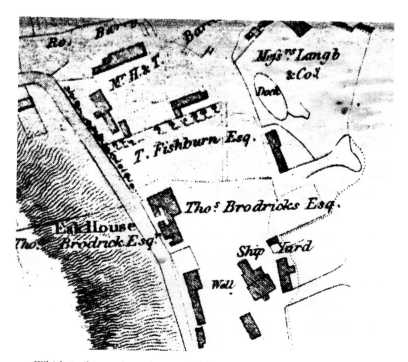

29. Whitby's shipyards as they would have been in the late 1700s and early 1800s are shown on this early map. The road on the left of the map has now become Windsor Terrace.

30. J. Y. Williamson of Castleton was one of the many rural craftsmen who, in 1918, could build you a new dairy table for the princely sum of one pound, two shillings and sixpence.

Residence—34, Cliff Street. Works—31, Cliff Street,
WHITBY,............................ 189 2

DR. ⁘ TO ⁘ WILLIAM ⁘ CHAPMAN,
Builder & Monumental Mason.

HEADSTONES RE-LETTERED AND CLEANED.

Dealer in Chimney Pots, Fire Bricks, Sanitary Pipes, & Cements.

Mar 30 Rep Mr Gibson Property Church Street £ 6 0
caused by the Fire
as per Agreement 3 3 0 0

Settled May 3rd 1892.
Wm. Chapman.

31. Cliff Lane had only recently been renamed Cliff Street in 1892, when Bill Chapman, a local resident, received £3 payment for repairing the fire-damaged property of Mr Gibson in Church Street.

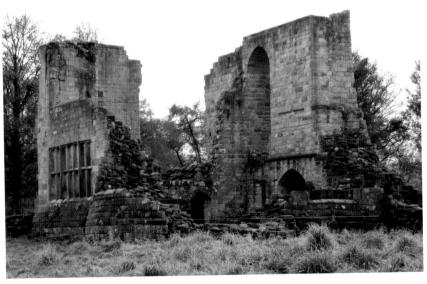

32. Old Mulgrave Castle, once the seat of the De Mauley family, rests in ruins in the centre of Mulgrave Woods. This, together with the remains of crumbling walls, is virtually the only visible remnant of what must have been an impressive stronghold.

HEARSE ROAD = GREEN LANE

The old traditional route taken by horse-drawn hearses attending funerals at the old churchyard on the cliff top involved a long detour via Green Lane (then literally a steep green country track). Many local families looked down on this practice and insisted on being 'churched' properly by having their departed relatives carried up the 199 steps. The long steps and benches to be found up the length of the 199 steps are in fact stopping places and coffin rests for the bearers.

HELL = HELL(E) = HELL LANE

Hell(e) was an area of land that once stretched from the western end of the bridge to the start of Haggersgate. St Anne's Lane, the passageway leading down from Flowergate alongside the former Woolworths premises, was once called Hell Lane. The name has ancient Scandinavian origins, 'Hell' being an old word meaning 'dark'. There has been speculation that Ellerby Lane, on the other side of the river, may have simply been Hellby Lane (i.e. the town side of Hell Lane). Hell or Hela is the goddess of the dead in Scandinavian mythology. She was the child of Loki and the giantess Angurboda and dwelt beneath the sacred Ash (Yggdrasil).

HEWISON BANK (1871)

Robert Robinson, a coachbuilder, lived in Hewison Bank, Bagdale, in 1871. This may be the house on the footpath that still exists from Spring Hill to Meadowfields, and was probably named after a former resident.

HIGH FELDE = HIGH FIELD

High Field comprised 200 acres of land described as 'contained in all lands between the outside of other lands near the abbey as far as Long Syke and the boundaries of Stainsacre'. Whitby Lathes stood in the middle of it and it is probably the same area mentioned in old records as 'High Whitby'.

HIGH STREET

This was a term rather than a designated street. A number of streets have had this name over the years, including Church Street, Baxtergate and Flowergate (1700s). Baxtergate was also known as 'Kings Highway' and 'Via Regis'.

HILDA'S WELL = HILDTRUUELLE / ILDREUUELLE (eleventh century) = HILDERWELL / HYLDERWELL (1200s–1300s) = HINDERWELL (modern)

Hinderwell takes its name from St Hilda's Well, which is still to be seen in the village churchyard.

HOGHERD HILL (1800s)

An old name for Pond Hill on the Whitby to Scarborough road, the name presumably meant the hill road used by hog (pig) herders.

HOLE OF HORCUM

This was a large cliffside stone quarry that echoed the name of the geological depression above Saltersgate. Horcum may have derived its name from a former settlement amongst oak trees (i.e. Oak-hamlet). The quarry situated on the edge of the East Cliff has long since fallen into the sea. Up until the 1980s, a small depression near the cliff edge existed as its only remainder. This place was popular with solitary campers. The name was colloquial but does appear on a number of maps.

HOPPET

An alternative name for a lock-up gaol for punishing minor crimes.

HORSE CLOSE

In 1541, it consisted of five acres of land 'north of the Knolles' near Saltwick, where horses were kept. In 1778, it was still known by the same name and was owned by Richard Ellison.

HORSE WYNDE = HORSE WAY

This was one of the many horse ways that existed in the town and ran from 'Town End', near the Seaman's Hospital in Church Street, up what is now Boulby Bank towards the Ropery, where it ran parallel with that road. It then descended the Horse Road (Donkey Road) at the southern end, emerging on what is now Church Street close to the bottom of Green Lane. This route was used to get from Whitby to Spital Bridge at high tide. Another similar horse road ascended from below Ripley's Buildings, crossing the Horse Wynde, and came out in Green Lane behind the workhouse (now St Hilda's Business Centre). The workhouse building (also known as the Poorhouse) was built on a plot of land called Little

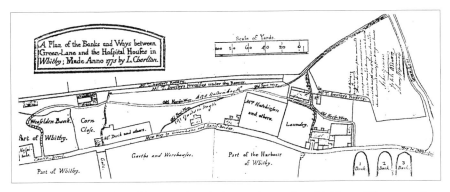

Lionel Charlton's plan of lower Church Street shows the old Horse Way as well as Wesselden Bank, Corn Close, Boulby's Ropery and other features in 1773.

Close (1794). A previous poorhouse was situated close to the bottom of Boulby Bank in 1726.

HUNTER'S LANE

A local property owner, Mr Hunter, gave his name to this lane, which later became Hunter Street.

HYNGANDHEUE = HANGING HEUGH

Two names given to an unknown place recorded as being close to Dunsley Village (possibly Raithwaite?).

INTAKE (1545)

A close of land was owned here by William Postgate of Sleights in 1545. The land was at that time let to Thomas Cockerell Jr and was probably an *intake* or enclosure of former moorland or forest lands.

IRON CHURCH = IRON HALL

A prefabricated church was erected on the West Cliff to serve the new West Cliff Estate. It was called St Hilda's and was later replaced by the stone church of this name close to West Cliff School. The iron church stood almost on the same site as the modern church but was moved, first on to Tucker's Field and then to the Back of St Hilda's Terrace (the modern street sign reads: 'Back St Hilda's Terrace'). The square of land it was built on is still visible as a small square green at the corner of Crescent Avenue. Confusingly, the name St Hilda's Terrace actually referred to what we

The old iron church as it appeared when originally built.

now call the Back of St Hilda's Terrace, while what we now call St Hilda's Terrace was originally called New Buildings and King Street.

JACKASS ROAD (1828) = ASHES WELL LANE (also 1828)

This former donkey road is now only a narrow cobbled alley with steps that connects Newton Street and Walker Street (behind the Catholic c church). It was, in much earlier times, the main road from Baxtergate connecting with the road along the sands at Upgang. Its alternate name, Ashes Well Lane, referred to a public well that stood here in a larger area called the Ashes or Eshes. It appears that, as it became narrower, another route was chosen, leading from the end of Baxtergate, up Union Road and Ralley Bank to the back of St Hilda's Terrace, where it continued to Upgang. The upper part of this new route towards Upgang was widened in 1670 and became known as Upgang Lane.

JOHN CAIL'S FARMHOUSE (1800s)

John Cail's house, a farmhouse, was described as 'belonging to the Presbyterian Chapel' and situated at the 'Nth. West of Whitby'.

JOHN CAMPION COATE'S HOUSE (1817) = MANSION HOUSE = THOMPSON'S HOTEL = RESOLUTION HOTEL

John Campion's house was described as 'the best built stone house in Whitby'. It was originally built by John Yeoman on the corner of

The Resolution Hotel, Flowergate, had no shop premises beneath it when originally constructed.

Flowergate and Skinner Street, with stables down the yard opposite, and became successively Thompson's Hotel, the Crown Hotel and the Workingman's Club before its present usage as the Resolution Hotel.

KATEWICK = KATEDYK(E) = CATWICK

A farm just above Sneatonthorpe held by George Burn in 1816. The word *katte* is a Viking one meaning 'cats', while a 'dyke' was a boundary ditch or furrow.

KIDDIES CORNER

A name given to the lower-level area close to the bridge end of Baxtergate. When the buildings known as Boots Corner were in existence, children were permitted to fish from it but adults were not. A sign saying 'Fishing for Children Only' was widely ignored and local adults, when challenged, had a ready reply saying that they were fishing for children, not fish!

KILLING NAB SCAR / SCAUR = KILLING NOBEL SCAR (1612)

An ancient hawk-hunting area at Newton Dale near Goathland.

KING STREET (1828)

The street between the Coliseum area and the rear of Victoria Square later lost its name, being declared 'unadopted'. The royal name 'King Street' had also originally been given to 'New Buildings' on Flowergate (now St Hilda's Terrace), but the name was either never adopted or was lost, possibly because of the erection of St Hilda's temporary iron church whose name became associated with the street.

KIRK MOOR YAT

The point where the Whitby to Scarborough road crosses Kirk Moor Beck has a number of earthworks, including remains of a moorland church (kirk) or chapel that were still visible in the 1990s. The word *Yat* is local dialect for *gate*.

LADY HARROWING'S DRIVE & LOW STAKESBY = LOW STAKESBY HOUSE (1817)

What was once a service road to the Harrowing mansion and estate is now a footpath leading through the large iron gates from Stakesby Road to Auckland Way area.

Though the Harrowings owned the estate, Lady Harrowing's title of Lady was not official; it was purely a term used by local people. The estate was

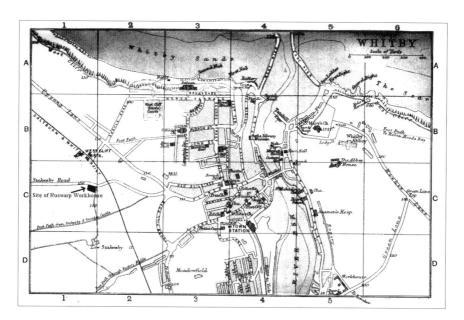

An early map features both the footpath to Stakesby across the Harrowing Estate and (superimposed) the site of Ruswarp workhouse. Royal Crescent is unfinished.

once a series of fields stretching from Chubb Hill to Castle Park. The main building here, known as Low Stakesby House, was once stated to be one of Whitby's finest buildings when it was in the occupancy of Abel Chapman.

A footpath through the former fields ran from Stakesby (considered as a separate village as late as the early 1960s) to Spring Vale. It was edged on both sides with smart metal railings and it crossed a stone bridge (over the West Cliff station railway line), passed a farm on the hill above the present doctor's surgery and emerged into Spring Vale from the steps & pathway that cut through the surgery car park.

LARPOOL = LEIRPOL (1544) = LAYER POL

This area of town has been historically recorded with a wide variety of spellings. The name appears to be Viking in origin and means either Camp Pool or Camp End, depending on the spelling.

LARPOOL HOUSE (1817) = LARPOOL HALL

In 1817, Larpool Hall, or a forerunner on the same site, was the home of Edmund Peters and was considered one of the best houses in the area. Edmund Turton is also listed as a Victorian owner of the building. A largely unknown stone-lined tunnel stretches beneath the lands around Larpool Hall and emerges on the side of the bank just below the country road from Helredale to Ruswarp.

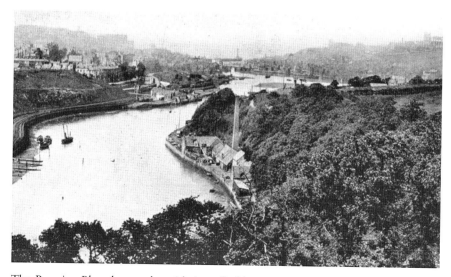

The Prussian-Blue dye works with its tall chimney was once a prominent building when viewed from above the woods at Larpool.

LASAM CLOSE (1545)

A now unused area in Whitby, in 1545 it was owned by William Postgate of Sleights and was being let to Thomas Cocerell (Cockerill?) Jr. The name Lasam may be a personal one.

LATHE CLOSE (1778)

This was three fields totalling 30 acres that in 1778 belonged to Mr T. (Thomas?) Linskill, who also owned an adjoining long field (Laith), called Potter Nook. This appears to have been let to, or subsequently owned by, a Mr J. Yeoman in the same year.

LECTOR NAB = BATTERY POINT = LECTOR ROCKS

A rocky nab (promontory) that jutted out to sea just beyond the present Spa buildings. It fell into the sea leaving only Lector Rocks remaining. Lector Nab once contained a number of platforms on which were situated a battery of 32-pounder guns used by the Whitby Volunteer Artillery for the defence of the town. They were still in place in 1859. The rocks were also used for religious gatherings by travelling preachers (a lector being a reader or lecturer).

This pre-1900 half-tone picture appeared in a local guide book, providing one of the few surviving pictures of Lector Rocks and Nab.

LITTLEBECK / LOW GUEBECK = LOW QUEBEC

Low Quebec is a rural area just outside Whitby that gave its name to the village of Littlebeck. A farm called Low Quebec still exists. The name has no connection with the size of the beck (stream) running through the village, but is instead a corruption of Low Guebec, a name with French origins meaning 'low area where the river narrows'. The French origins may have historical connections to French Catholic priests, including the famous French-trained Nicholas Postgate, who frequented the area when Papism was banned in England. Another French connection relating to the smuggling of French priests into the district is retained in the name of Calais House on the Whitby to Middlesbrough moor road, named after an earlier farmhouse with the same name close by.

LITTLE JOHN CLOSES

Fields situated near to Robin Hood Closes on the Stainsacre to Robin Hood's Bay road. Both fields are connected to a legend that Robin Hood and Little John stayed at Whitby Abbey from where they shot longbow arrows into the distance in a competition. The closes (enclosed fields) are supposedly where their arrows landed.

LOBSTER HALL

Now a separate accommodation unit belonging to Bagdale Hall on Spring Hill, next to the footpath leading to Meadowfields. It was said to be built by a guardsman of the Whitby to York stagecoach, who made a tidy profit from carrying and selling lobsters to York residents. In 1907, it was Spring Hill School (private), and then the 'Princess Club', a private club for local businessmen. Prior to its current use, it served as crockery and catering supply wholesaler's.

LONDON WHARF (early twentieth century)

A wharf on Church Street situated next to Smale's Yard and Gallery, possibly used by coal ships that berthed overnight on their way to the capital from the coalfields of the north-east.

LOW STREETS

The collective name once given to Grape Lane and Sandgate.

LYTH = LYTHE = HLITH = LI / LIZ / LIHZ (1100s) – LYETH (1200s–1400s) = LEITH (1500s)

In 1831, Lythe parish included Barnby, Borrowby, Ellerby, Hutton Mulgrave, Lythe, Mickleby, Newton Mulgrave and Ugthorpe. The name is derived from the Scandinavian *hlith* meaning sloping meadow.

MARKETS

In the days of the abbey, a 'scandalous' Sunday market on the abbey plain was closed and moved to the town, where it was directed to be held on a Saturday.

There have been a number of other market places in the town, including a fish market on the old cobbled quay beneath New Quay. Fish was also sold on the east of the harbour at Fish Ghaut and on the Fish Pier. Potatoes were sold on St Anne's Staith and in the Potato Market as well as at the bottom of Golden Lion Bank in the Old Market. This market area was previously much wider, but was encroached upon by other buildings. It formerly stretched further back (westwards) at least as far as the Angel Hotel entrance on Baxtergate. Similarly, Church Street Potato Market would have formerly been a great deal larger as it was also the site of the Viking *Thingwalla* Market or toll booth.

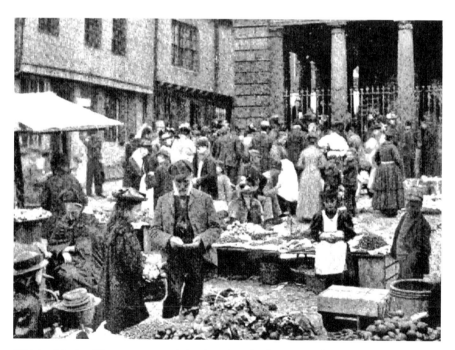

Whitby Market Place was a much busier place in the 1800s than it is at present.

The present (east side) Market Place was once a thriving hub of commerce supplemented by butcher's shops lining Sandgate (known as the Shambles). Slaughtering was carried out on the premises. Fish was also sold on the fish pier, while the north side of the Market Square appears to have been occupied largely by public houses.

Taxes were collected and local disputes settled in the Old Town Hall, and there is strong evidence to support the belief that its spiral staircase once descended into cellars. There is at least one record stating that bonded custom vaults existed below the Market Square.

A 'modern' Market Hall was built over part of the old Shambles at the south end of the Market Square. This was taken over for the 'war effort' in the Second World War, and goods including bananas were said to be stored there en route to other ports. The building later became Burberry's clothing factory and is now the Shambles public house with a shop unit arcade below.

A 'Cattle Market' is marked on a Victorian map, situated close to the railway line on the long, raised section leading from the bottom of Waterstead Lane to North Road.

MARKET CROSS

The Market Cross mentioned in some documents is believed to be the same as the 'Great Cross' mentioned in others and may have stood (in its present position) in the centre of a joint abbey and church graveyard. It was described as being 'in the abbey cemetery' in 1417. Though it may well have been used as a market cross, its real purpose would appear to have been a religious cross or central reference marker for mileposts and other crosses such as the mile cross at Stakesby (see WISHING CHAIR). It has survived at least one attempt at removal when it is said that those attempting to cut it in half to take it away were foiled by its large metal core.

In Victorian times, this same cross was mentioned as the centre for Easter celebrations:

> On Easter Monday and Tuesday at Whitby, a fair for children is held in the space between the parish church and the abbey, when they assemble to 'troll eggs' in the fields adjoining … They are first boiled hard in some dyeing preparation, then otherwise streaked on the coloured ground thus obtained, and marked with the initials of the parties to whom they are presented, while some are further embellished with dots of gilding. On Easter Monday likewise, the boys have a practice of assaulting females for their shoes, which they take off unless redeemed with money; and on Tuesday it is the girls' turn with the boys in the same way, when we have known men's hats removed from their heads when the joke could be safely exercised, and redeemed with a shilling.

Another market cross may have existed at Flore (Flowergate), where the area around the present roadway roundabout is known as Flowergate Cross.

MARKET STEDE

According to the early Whitby historian Charlton, in 1609, the Market Stede (House) in the Old Market Place at the Western end of Whitby Bridge was 'furnished with shops and lofts for the convenience of the market'. The market was removed to the east side in 1640.

MARS DALE

The valley leading inland from Sandsend was said to contain a small Roman temple dedicated to Mars, which may or may not have been situated on the same site as a Viking one dedicated to Thor; hence an earlier name for Sandsend was *Thordissa*. Some historians have speculated that the temple(s) may have been situated at what is now Holy Well Farm.

MARSINGDALE CLOSES (*c.* 1654) = MARSINGALE CLOSE

A field area close to the present Skinner Street and described as being 'above Tenter Close [the Paddock] and Bakehouse Garth'. Marsingale is a local surname in the town.

MAYFIELD

The May Field (the field where the maypole festivities took place on May Day) gave its name to Mayfield Road. The actual field stood at the upper point of the present road, on the left, just before the roadway roundabout. Weighill's Tannery stood in the next field, below it, towards Whitby.

MEADOW FIELDS HOUSE / MEADOWFIELD PARK / MEADOWFIELD ESTATE

Situated on the site of the present Meadowfields housing estate, Meadow Field House was the mansion of Henry Simpson in 1817. The original Meadowfields estate stretched as far as the river but was sold off in 1853, when the Meadowfield Park (now simply called the Railway) residential housing area was begun. Park Terrace is the only remaining reference to Meadowfield Park.

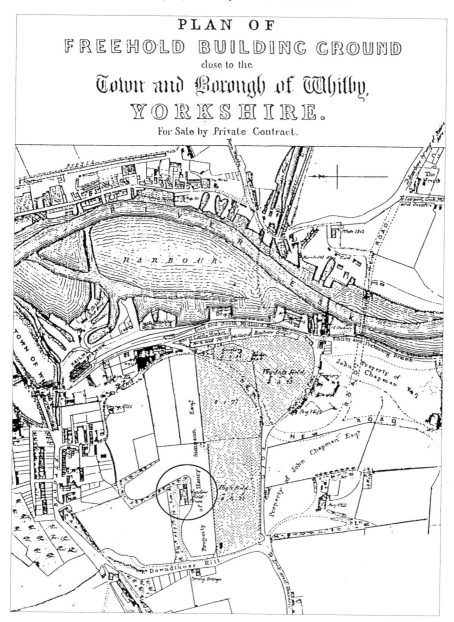

Meadow Fields House (ringed) can be seen here on the sale map that was produced when the estate was broken up.

MEETING HILL = MITTEN HILL = METAN HILL

There are, or were, two Mitten Hills close by each other at Hawsker. They were evidently used by George Fox in 1654 as a meeting or gathering place for Quakers. Contrary to popular belief, Mitten Hill did not take its name from these meetings, because a much earlier Whitby Abbey document mentions the place, then spelt Metan Hill.

MEETING HOUSE

This expression invariably applies to the Quaker Meeting House on Church Street which appears to have been hired for many public meetings. The building (now commercial premises) still stands in Church Street between Bridge Street and Grape Lane. Whitby's first purpose-built meeting house was built here on a toft of land owned by Isabel Sutton in 1676, though the land had been acquired seven years earlier for the purpose. The present building on the same site dates from 1813. Quakers were prominent in the Whitby business community and were on the whole exceedingly well respected, fair and honest in trade. A few disagreements took place between them, particularly during times of war; some Quaker owners fitted guns to their ships for self-defence. Another disagreement took place when some members of the Quaker community breached the 'vanity' code of not using gravestones to mark the place of their buried dead. A visit to the Quaker graveyard in Bagdale (over the wall, next to the fishpond in Pannett Park) shows that only a few markers are present. The cemetery in Bagdale was instigated in 1659, on a plot of land purchased from Nicholas Sneton, a local shoemaker.

The shops opposite the Old Town Hall in Church Street were once the premises of local Quaker bankers Jonathan and Joseph Sanders (sometimes spelt Saunders). The bank was founded in 1778 in the shop at No. 79. The two brothers appear in Mrs Gaskell's novel *Sylvia's Lovers*, portrayed as the 'Foster Brothers'. The Sanders family originally came from Guisborough to start a linen and sailcloth manufacturing business using eleven looms in the yard behind the bank premises which were originally purchased by the brothers' grandfather, Jonathan Sanders. The name 'J. Sanders' cut into the glass panel above the shop door was removed while alterations took place in the shop during 1996, with the intention of replacing it when work was completed.

METHODIST CHAPEL

There were a number of Methodist chapels in Whitby, most of them situated on Church Street, including one on an elevated plot of land at

Primitive Methodist Chapel Yard and a Wesleyan chapel up a long flight of steps, close to what is now Bobbins.

MIDELWODE = MIDDLEWOOD

A previously wooded area close to Fylingthorpe and Robin Hood's Bay.

MILLS

Ruswarp Corn Mill is said to date back to the days when the abbey was active. In 1541, it was owned by John Pereson. In the same year, a 'wind-miln' is recorded as standing close to the abbey 'upon a mount'. Arundel House Windmill existed in 1828 and many village mills lasted long enough to be photographed. The largest mill in the district was Union Mill, which stood on the site of what is now Harrison's Garage at Flowergate Cross. It was owned by shareholders who received their dividends not in cash, but in flour; a small card was punched every time they received these dividends.

MILLERS FIELD

An old field name at Airy Hill, possibly the site of an ancient mill.

MILLER'S SANDSEND

An ancient name for Airy Hill Farm is Miller's Sandsend. However, there has been speculation that it may have originally been called 'Miller's Sanction'. An alternative explanation for the name dates back to when the sandy riverbed was used at low tide as a road between Ruswarp Mill and Whitby. It may have been at this point that the sandy trackway ran out.

MILL FLATS = WINDMILL FLATS

This was the site of a windmill in 1394, a little east of Whitby Abbey.

MILL HILL = WINDMILL HILL

A hill above Sneaton Mill in 1297.

MONGREVE = MOULTGRAVE = MOULTGRACE = MAULEYGRAVE = MULGRAVE

Names used by Leland, Camden and others to describe Mulgrave Estate near Lythe. The term 'grave' anciently meant a place of long-term rest or

Opened by Rev. John Wesley, June 13th, 1788.

Modern bungalows now stand on the site of the former Wesleyan chapel in Church Street. Only the steps remain.

The Union Mill.

WREN'S MILL
Old Whitby Mills

Anderson's Mill.

Three of Whitby's mills, all of which have now vanished completely.

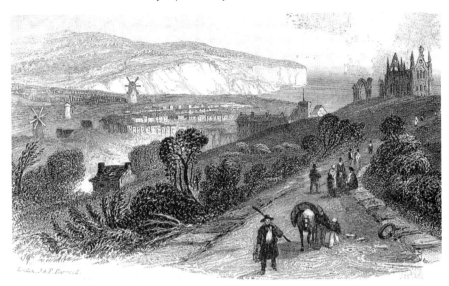

Another view of the three mills, as seen from the old main road from Whitby to Hawsker.

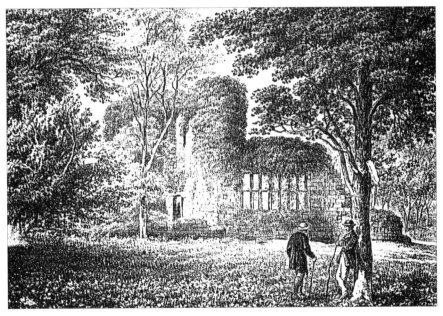

Old Mulgrave Castle as it was in the early 1800s. The present castle of the same name is in nearby Lythe.

residence and not just a burial place, hence Mauleygrave simply meant the residence of the (de) Mauleys, one-time owners of old Mulgrave Castle. The modern castle replaced this older one whose ruins are still visible in nearby woods.

MONKMAN'S BUILDINGS

Named after their builder, a Mr Monkman, these buildings were described as 'the tall buildings at the bottom of the church steps' – i.e. the rounded corner block opposite the entrance to Kiln Yard.

MONK'S PARK

A former name for Ruswarp fields, though there appears to be no evidence that the monks of Whitby Abbey had any close links with the area, so the name may be purely colloquial. An ancient crossing to Glen Esk (at the shallowest part of the river where it is still possible to wade across today) is evidenced by an old packhorse bridge close to the river, over the railway line near the present swing gate from Fitz Steps.

MOORGATE LIEZ = MURGATE LIEZ = MOREGATE LIEZ = MOORGATE LEES

This farmstead was held by George Bushell in 1541. It consisted of 5 acres of land in 1788.

MOORSOME'S BOIL HOUSE

This building, used for boiling whale carcasses in order to extract oil and gas, stood on the site of the later Whitby gasworks at the bend in the Esk below the later railway viaduct. On the same premises there was also a timber yard and timber pond owned by Mr Moorsome. *Finks*, the fatty portions that remained after extracting whale oil, were used as manure on local fields. The smell was said to be 'extremely unpleasant'.

Though short lived, the whaling industry brought much prosperity to the port. Sometimes voyages were hazardous and a number of ships got into difficulties, sometimes not so far from their home port. In 1838, for instance, the newly refurbished *Phoenix*, on her way to the Davis Straits, was under tow by the steam vessel *Streanshalh* in order to clear her of the piers because of atrocious windy and wintry spring weather. Having cleared the harbour, the towline broke loose and the whaler drifted behind the East Pier where she stayed until the next spring tide. By the time the boat was brought into the harbour, the vessel was badly damaged to the

The *Phoenix* whaling ship in 1838, just after it got into trouble when barely outside Whitby Harbour.

extent that her bottom timbers were floating in the hold. The *Phoenix* was later towed to Barrick's shipyard, where she was sold for £500. Though refurbished for the American timber trade, the ship sank some time later with the loss of part of her crew, by which time Whitby's whaling trade had come to an end.

MORGUE

The town morgue was once situated in a building on Green Lane. It closed down in the 1960s.

THE MOUNT

Two areas in Whitby have been known as the Mount, namely one at the upper part of Cliff Street where the Mount Boys School (formerly the Lancastrian Boys School) was established. The equivalent Lancastrian Girls School was situated on Cliff Street (Cliff Street School), in what is now the car park at the rear of the Nisa supermarket on Flowergate.

The second area known as the Mount was to be found on the east side of the harbour, diagonally opposite the building used as Larpool old people's home. It was situated on the corner of Larpool Crescent and Helredale

Road, where council houses and flats now stand. A large mansion also called the Mount (1828) stood on this spot and was still known by this name when it was demolished in 1960.

MULGRAVE CASTLE INN

Well known to smugglers, the Mulgrave Castle Inn once stood on the cliff top at Upgang. It has long since fallen into the sea. Its last landlord was a Mr Cornforth, who is believed to have moved to the Beehive Inn at Newholme in 1895, when the cliffs on which the old inn stood became unstable.

NEWHAM = NEWHOLME

This Whitby village once had its own mill. Its name is pronounced 'Newm' by local residents and means new (marshland) dwelling.

NEWTON (1396)

An old name for Newton Mulgrave, a village that is now little more than a hamlet. Newton (New Town) probably got its name at the same time as the nearby village of Newholme.

NEWTON HOUSE

Newton House, a building in the ancient township of Ugglebarnby, was built by local merchant Jonas Brown. On an obelisk near the house is a Latin inscription to commemorate his 'industry and perseverance, in converting wild moors into pleasure grounds'.

NEW QUAY

There have been at least three New Quays in Whitby. The first was built on the south-west side of the bridge and is now covered by New Quay Road. Its cobbled surface can still be seen beneath the present road by descending the steps down to the river and looking beneath the present road. Another New Quay was accessed via New Way (see above). The present west-side, fish market site was also built as a new quay to modernise the harbour facilities. The once split-level Pier Road was transformed into its present form at the same time.

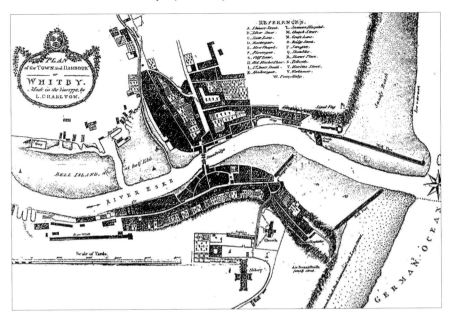

Lionel Charlton's eighteenth-century map was completed shortly after the opening of the New Way in Church Street.

NEW WAY (1775)

The name refers to the lower end of Church Street from the earlier 'Town End' at the bottom of Boulby Bank towards Spital Bridge. The name indicates that this may have been the first time that some sort of permanent direct route had been established along the harbour sands between the two points. The name New Way was also applied in the 1800s to an alleyway close to upper Church Street beyond the Market Place, when an access was briefly provided to a new quay built on the harbour side in that area (below what is now the Duke of York pub).

NEW WHITBY

A name given to the west side of the river during the 1800s, when many new developments were taking place. This shows that Whitby itself was considered to be on the eastern side of the Esk and adds weight to the theory that Hamessom, mentioned in a medieval deed of William de Percy, i.e. 'seaport of Whitby and Hamessom', could have been a settlement on the west bank of the river.

OLDESTEAD (1541) = OLD STEAD (1778)

It was described as being 30 acres of land on the side of the alum works at Saltwick. It reached as far as the farmhouse at High Whitby, close to the former Whitby High Light (Lighthouse).

PARADE (1794)

This was a name given to all or part of the abbey plain in 1794, and has no connection to the parade of shops on the West Cliff with the same name.

PARADISE ROW

In 1817, Paradise Row was said to be 'on the west of and behind the house of Richard Rudyard'. It was situated close to the present Seaman's Mission building and the nearby shell shop (once a tinsmith's premises). All that remains today is part of Paradise Yard.

Paradise Row has now gone forever but Tinner Hall's shop nearby remains in the form of a shell-craft products shop in Haggersgate.

PEDLYNTON FIELDS (1541) = THISTLE'S FIELDS (1950)

These fields between Green Lane and the abbey are now called Thistle's Fields. Pedlynton may have indicated the name of a previous owner or farmer, as is certainly the case with Thistle's Fields.

PENNY HOLE

A place under Huntcliffe, north of Staithes, described as 'affording a safe landing place haven, even in the stormiest weather'.

PIERS

The first mention of a pier being built at Whitby is in 1632, when Sir Hugh Cholmley built one from oak piles, which was filled with fallen stones from the cliff. It stretched diagonally across the harbour towards Tate Hill beach from a point somewhere near the present Scotch Head.

The term 'Pier End' was in ancient times given to the end of Haggersgate, where a road then went along the Cragg towards the beach. This old pier and an original post (still in use) for tying up boats can still be seen by descending the steps to the harbour at the end of St Anne's Staith, close to the Pier Café. This area was known as 'Coffee House End', taking its name from a coffee house that once stood at this point.

In 1710, the town's present piers (and Battery Parade) were built. The East Pier was slightly extended with a rounded end in 1741, at a time when

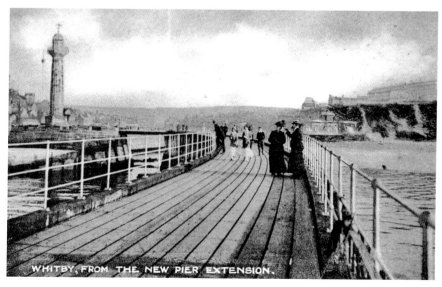

A postcard from 1910, showing the new extension to the West Pier.

A 'Walking Man' in the process of building the pier extensions.

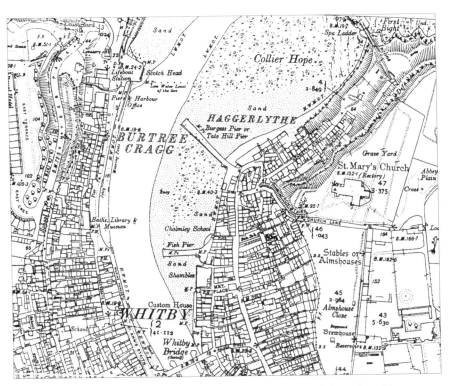

The names of Tate Hill Pier and Burgess Pier are both recorded on this old map at a time when both names were in common usage (*c.* 1920).

John Walker was a Piers Trustee. In 1777, Pier Road, as we know it, began to be built and in 1787 both piers were, or were planned to be, extended to their present lengths, which they reached in 1817, with the West Pier lighthouse being completed in 1831. The earlier bull-nose end of the East Pier is still visible within the present stonework to anyone walking along it.

Both pier extensions were completed in 1910, having been constructed using large moveable cranes, which rested on the seabed, known as 'Walking Men'.

FISH PIER = NEW PIER = LITTLE PIER (1702) / BURGESS PIER (1817) = TATE HILL PIER

Both the Fish Pier and Tate Hill Pier were known at various times as the 'Little Pier'. The original 'Little Pier' was extended in length in 1768 and heightened to form the present Tate Hill Pier in 1778. The west pier was heightened at the same time. The Fish Pier, also known as 'New Pier' or 'Little Pier', was first built in 1789 when Tate Hill Pier was extended. The name Burgess Pier refers to funds raised by the Burgesses of the town, who were the earlier equivalent of elected councillors.

Elections for councillors were often a riotous affair in former times and many songs and ribald jokes, which were sung in pubs, have survived. For example:

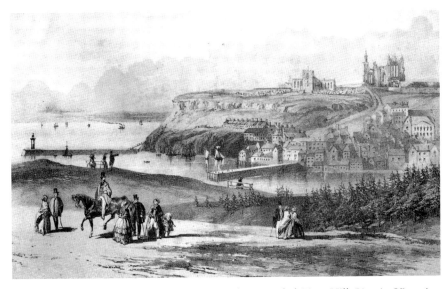

A view of Whitby's east side and the newly extended Tate Hill Pier in Victorian times.

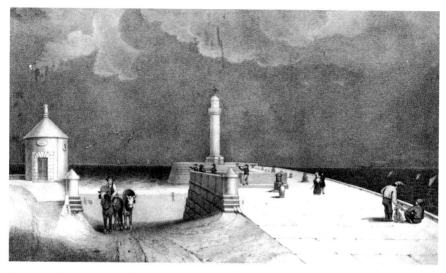

The pier slip is pictured here being ascended by one of Whitby's old characters, the Sandman (sand seller).

> Aint they a nice collection, after such a great election,
> It'll be spend spend spend 'til the three years end
> and then off in a new direction.

In the 1935/40 council election, the following suggestive saying was going round the town, referring to councillors Cox, John Thomas Stoney and Paylor:

> Whitby has 28 councillors – There's 27 without Cox
> Leaving only one John Thomas between 'em.
> All those without Cox look pale but only one is Paylor.

Old residents recall many similar ribald or blackly humorous verses circulating in the town, many of which would be unprintable. Harry Paylor, son of 'Jonty' Paylor, is credited with composing many of them.

Another song about a local resident sailor with a wooden leg was apparently sung more with affection than to mock his affliction. It went:

> Peter Campion ploughs the sea. He's half a man and half a tree
> He's been in workhouses and in jails but still he's loved by Florrie Scales

PIER SLIP

The slipway leading from Scotch Head to the beach at the end of Pier Road.

PLAT(T)S

There were once many Platts around Whitby, though the name is now only recognised by older residents. Platts were small flat areas of ground, behind and in between houses on a hillside. They were used for drying washing, as children's playgrounds and as general gathering places. In other areas these would be called yards, but in Whitby a yard is a long, narrow passageway, usually around 3 feet wide, which was left during construction so that pedestrians could have access between new buildings.

POST OFFICES

Post Office Yard was the site of the first public post office in Whitby. It stood at the west end of the bridge with its entrance up a yard on St Anne's Staithe (behind what is now Ladbrokes bookmaker's). It probably occupied the same room that became the smallest pub in Whitby, the Central Bar, more popularly known as the Bass House. It appears to be the only example of a 'men-only pub' in the town. The establishment sold only Bass beer and consisted of a bar stretching across its narrow width with only two or three small round tables for customers. It closed in the 1960s.

Until the 1950s, Whitby postmen walked to and from Robin Hood's Bay twice a day to deliver mail.

Another post office was once situated in Church Street where it meets Bridge Street and yet another (at a different period) on the opposite side of Church Street, near the entrance to Ellerby Lane. Whitby's General Post Office, including a telephone exchange, was later established on Baxtergate in the now rebuilt Yorkshire Trading store. Postmen used to deliver as far as Robin Hood's Bay on foot. The front exterior remains the same and still carries the elaborately carved 'Post Office' nameplate above the old entrance door. The Post Office closed in the 1990s, when postal facilities were incorporated in the new Co-operative supermarket on Langbourne Road.

SUB POST OFFICES

Whitby town's sub post offices, most of which have now closed, were placed at various points throughout the town, including the upper part of Church Street, on Skinner Street, on North Road, on Abbot's Road and on the Parade.

POST ROAD

What is now a footpath from the Switchbacks to Bagdale was the original post road on which postmen on fast horses would transport mail to and from the town.

POTTER NOOK

A long field 'adjoining Lathe Close' in 1778.

PRESBY = PRIESTBY

Said to be the name of the area outside the abbey and where clergy lived, supposedly at the time that the abbey was active or after its dissolution. Other contenders for the site of Prestby/Priestby are Robin Hood's Bay and 'somewhere' on the west side of Whitby harbour.

PRIMROSE ALLEY & BANK (1700s)

Primrose Bank was evidently a common descriptive name for the bank at the bottom of Flowergate that was later built upon and where Woolworths recently stood. Hell(e) Lane, now called St Anne's Lane, was also named (or nicknamed) Primrose Alley, in around 1740.

PRINCE'S PLACE = PRINCESS PLACE

This is perhaps the only example in the town of a street changing sex as well as name. It began as Prince's Place and changed to Princess Place purely by local mispronunciation. Between it and nearby King Street (see under KING STREET) was the town's former police station and courthouse, whose site is now used as a car park.

PROSPECT HILL

Before building took place, Prospect Hill was said to 'afford the finest views of the town and out to sea'. It is said that seamen who visited the port of Whitby would make a special journey to take in the view, making the 'Prospect of Whitby' a talking point throughout the maritime world. Though this is legendary, some credence may be given to the fact that this view inspired the name of a ship, the *Prospect of Whitby*, which was regularly moored at a London dock and eventually gave its name to the famous public house there.

PROSPECT PLACE

In 1874, the area now covered by Hanover Terrace close to Prospect Hill was called Prospect Place. The name was dropped or fell out of use and was adopted for another Prospect Place on the western side of the Esk. These buildings consist of a double row of houses built on the steep hillside by Gideon Smales, a ship owner, builder and merchant in 1816. They are constructed from fine herringbone stonework and, though built close together, afford panoramic views of the town and harbour from their upper floors. They are originally believed to have been tenement houses for Smales workers and may have had sailcloth looms in the upper garrets. The style of the houses is very similar to houses in inland cities, where accommodation was provided for cloth weavers below the upper work area.

PROSPECT ROW

This is the name of the small group of houses standing at the bottom of Green Lane and stretching along the bottom end of Church Street towards Spital Bridge. The houses took their name because of the harbour views experienced from them when they were originally built.

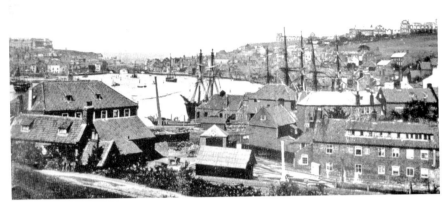

A Victorian view of the Spital Bridge area from Gallows Close, with Prospect Row in the centre of the picture.

PUBLIC HOUSES

Though some public houses are described in this book, a history of all Whitby's old public houses and names can be found in *A History of Whitby's Pubs, Inns and Taverns*, Colin Waters, 1992.

RAILWAY TICKET OFFICE = TOLL OFFICE

There were originally two of these round stone buildings standing at a point midway between Bog Hall and the former gasworks. Only one now remains from the days when tickets were sold here for the original horse-drawn railway. The ruinous building now fenced off in an allotment is an integral part of Britain's railway history and should have been preserved many years ago when in a much better condition.

RALL(E)Y BANK (1828)

This is the portion of Union Road (now Union Steps) that continues its path (across the road) between the front and back of St Hilda's Terrace.

RANTH'S WALK = RAUTH WALK = RUTH WALK = ROUTH WALK

There is no record of how it got its name, but like many other streets and passageways in Whitby, it probably took its name from a former owner or resident.

RATHRIG = RETHRIG = RETHRYG = THE RIG

The rig in question is a high ridge of ground beyond the footpath (an ancient flagged road) at the Stainsacre end of Golden Grove Woods. It gave its name to Rig Mill.

RAT PIT

This irreverent colloquial name for the Railway Inn or Railway Tavern persisted until the building was refurbished and became the Cutty Sark. It later became the Tap & Spile and was later renamed the Station Inn in April 2007.

RAW = ROW

Raw, close to Robin Hood's Bay, appears to be a local dialect version of Row (i.e. a row of houses); it appears as such on Thomas Jeffrey's 1775 map of Whitby and district.

RIPLEY'S BUILDING (1817)

Named after John Ripley, they were tenement buildings to the south of the square formed by the houses on Boulby Bank. Adjoining them were Smales' Buildings.

ROBIN HOOD'S BAY

The village is said to take its name from the supposition that the real life character had a fleet of boats here. The village was a smuggler's haunt from early times and once had its own town crier.

ROBIN HOOD CLOSES

This is situated near to Little John Closes on the Stainsacre to Robin Hood's Bay Road at Whitby Lathes. The earliest mention of the name appears to be 1713. Legend states that Robin Hood and Little John shot their arrows from Whitby Abbey and the places where these fell were named Robin Hood Close and Little John Close. The exact spots were marked by two stone pillars, probably actually boundary markers. One was being used as a farm roller in 1820.

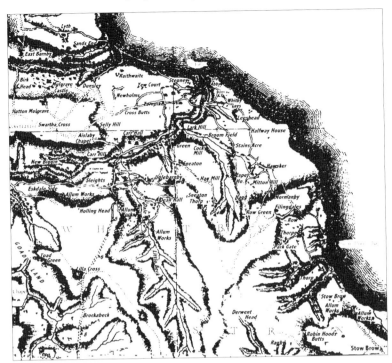

A section of Thomas Jeffrey's map of 1773 reveals some extinct common Whitby place names, including Row, Hag Mill, Lark Hill, Broom Field and Toad Green.

In the 1920s and 1930s, Robin Hood's Bay had its own town crier.

ROBIN HOOD'S BUTTS (1800s)

These are situated between Peak (Ravenscar) and Bell Hill near Stainton Dale. There is a variation on different maps as to their exact location. The name 'butts' is usually associated with archery, but has its origins in odd-shaped fragments of fields, which were also called butts. They had little use other than for grazing animals and archery.

ROPERY (WALK)

Though now associated with a single street, there were in fact many 'roperies' or rope walks in town. One of Whitby's earliest was situated in Arundale Hole. It was 240 yards long and was owned by Nicholas Harker, who, with his wife, died in a snowstorm on the Whitby to Scarborough road in 1816. The same ropery was later, in 1828, in the hands of Henry Goodwill. The street currently known as the Ropery was owned in 1775 by a Mr T. Boulby, who gave his name to Boulby Bank. John Holt Jnr had a rope-making business in a row of buildings known as Ropery Walk, where Clarence Place now stands. Mr Barker's ropery ran from the bottom of Waterstead Lane towards the town, in around 1800. Whitby's last rope walk was situated along the south side of Spital Beck, close to Spital Bridge.

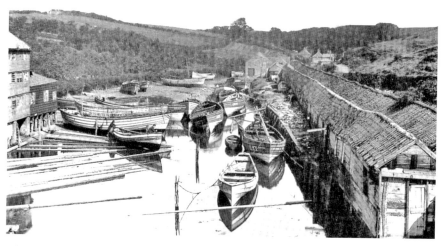

The old ropery buildings at Spital Beck (right) were in use until the days of the First World War.

ROYAL CRESCENT

This curved street was originally meant to be a direct copy of the famous Royal Crescent at Bath, but the developers ran out of cash before completion.

ROYAL CRESCENT AVENUE

This is the present Crescent Avenue. Its original and full name frequently confuses researchers who believe it to be 'The Crescent' of Bram Stoker's *Dracula* novel, a misconception often repeated in modern books.

RUNSWICK

Runswick village has suffered over the years from many landslips. The village is known for its Congregational chapel built in 1829, and Hob Hole Cave, where parents used to bring children with whooping cough to be cured by the 'Hob' that supposedly inhabited it. They would recite, 'Hob-hole Hob! My bairn's getten't kink-cough: Tak't off! Tak't off [Take it off]!'

RUSWARP = RISEWARP

A warp is an old name for a gathering of sand on a riverbed, making it shallow and suitable for crossing. Ruswarp appears to mean risen warp.

RUSWARP MILL

A corn mill is said to have existed at this point since Saxon times. Another one, built in 1752, was largely destroyed by fire in 1912, but was rebuilt and has now been converted to housing.

RUSWARP WORKHOUSE / POORHOUSE

This was built in Stakesby Road in 1804. The area is strictly in Ruswarp parish because the boundary between Whitby and Ruswarp runs through the centre of the Little Angel public house on Flowergate. The poorhouse was built in 1804 on the site of the modern bungalow on the western side of Lady Harrowing's Drive, which leads from Stakesby Road to the Auckland Way housing estate.

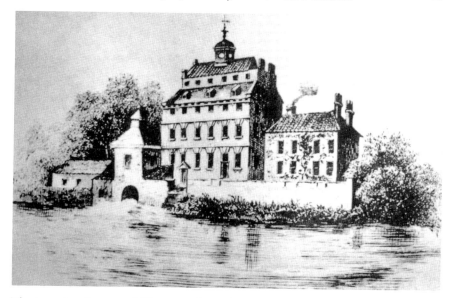

The imposing Ruswarp Mill as seen from the river in the 1800s.

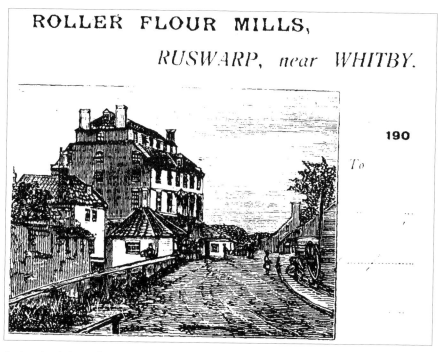

A sketch of the mill at Ruswarp as depicted on its letterheads in the early 1900s.

SAINTS

Given the historic connections with Whitby Abbey, it is not surprising that the names of saints constantly crop up in local place names.

SAINT ANN'S STREET = STAITHSIDE = SAINT ANN(E)'S STAITH

Staithside predated Saint Ann's Staith, but covered the same area with buildings on both sides of the street. On the harbour side, buildings were supported on stakes driven into the mud.

St Anne's Staithe is found on maps both with and without the final letter e and was built in around 1559. Improvements were made to it in 1676. There is speculation that this part of the harbour has ancient origins. Though the name is a Christian one (probably so-named by the abbey monks after Ann, mother of the Virgin Mary), St Anne is also a Christianised form of the pagan or Celtic *San Tan* (Breton for Holy Fire). There is evidence for this connection in other places in England such as at St Ann's chapel on Tan Hill, Midhurst, Sussex.

John Katterfelto, also known as Catterfelto, was a popular local pub owner who went under the name of John Carter in 1800. He is believed to have been a foreign immigrant whose name had been anglicised. He was also a jet worker and is believed to be the same man who was landlord (but not owner) of the Jolly Sailors pub on St Ann's Staith between 1823 and 1840; the owner was Mary Richardson in 1837.

SAINT ANNE'S STAITH FOUNDRY

A brass foundry was situated here in the early 1800s. It was owned by John Lowrie.

SAINT HELEN'S STREET & CHAPEL

It once stood north of the bottom of Tate Hill, facing the sea. The street with its small chapel fell into the harbour during one of the area's many landslips.

SAINT HILDA'S HALL

The hall still exists on Baxtergate behind the New Angel Hotel on New Quay Road. It was formerly used for local shows, pantomimes and other events, and later became Lawton's nightclub.

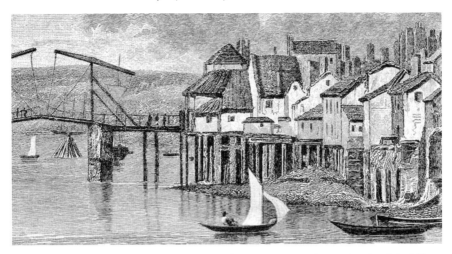

Before demolition, the Staithside part of St Ann's Staith consisted of buildings supported by stakes driven into the harbour mud.

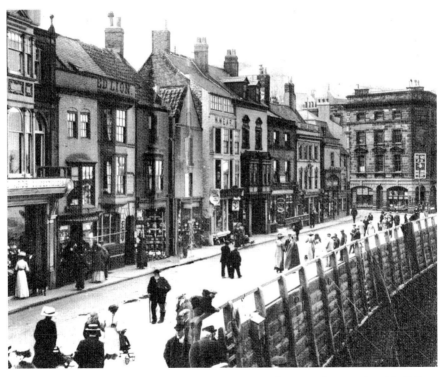

A lovely old view of St Ann's Staith in the 1800s, showing the stretch of buildings from the Red Lion pub to the Scarborough & Whitby Breweries' building.

SAINT LEONARD'S PRIORY

This Benedictine priory was founded at Grosmont around the year 1200 by Johanna de Turnham and was further assisted by the Fossard and de Mauley families. It was attached to the abbey of Grandimont (Grammant/Grosmont) in Normandy.

SAINT MARGARET'S LAUNDE = THOMCROSSEBUTTS = CROSS BUTTS

St Margaret's Land (*c.* 1175), now Cross Butts, is mentioned in an abbey charter as being given to maintain a light at the chapel or church in Aislaby (St Margaret's Light), presumably as a way-marker for travellers.

SAINT MARY THE VIRGIN

Saint Mary the Virgin is the full name of the parish church, now more popularly known as St Mary's. The first parish register dates to 1608, though the oldest parts of the church are said to pre-date the earliest part of the abbey by sixty years. Some historians believe it may in fact have started its life as an earlier Whitby Abbey. It was originally thatched, but in 1539 a lead roof was 'laid upon it', using lead taken from the abbey roof. The 199 steps were originally made of wood, probably salvaged from wrecks, because they were noted as being 'of various sizes and colours'. In 1788, there were 190 steps. Prior to 1817, there were 195, but later they were 190 in number again, later rising to 199. The parish church once had a 'Great West Door', the outline of which is still visible. The north wall was completely rebuilt from the ground in 1744. Records state that the original dimensions of the church, before erection of tower and transepts, was 103 feet long by 34 feet broad. This excluded the chancel, which measured 39 feet by 25 feet on the outside and measured 12 feet high 'with the church walls higher' in 1817. The transepts were said in that year to extend 34 feet, and exclusive of the buttresses and the tower it was measured at 26 feet square. Even the door was measured; it was 10 feet high and 4 feet wide. It is known that the tower was originally a third higher than at present, though the original tower may have been built over what is now the present entrance door.

SALT PAN WELL STEPS

Located at the bottom end of Church Street, this area originally had a small salt-making industry instituted by Sir Hugh Cholmley, using seawater in the 1600s. A public freshwater pump was placed in the small square at the bottom of the steps by William Scoresby in the 1800s.

SALTWYKE (1541) = SALTWICK

In 1541, land at Saltwick was owned by Thomas Newton. Part of these lands included Fermery Garth, which consisted of 5 acres between Spital Beck and the eastern side of New Gardens owned by Abel Chapman and William Frank in 1778. In 1788, Saltwick Farm included Saltwick Salt Works, which produced alum and/or sea salt. The hospital ship *Rohilla* was wrecked near Saltwick Nab in 1914.

SALTWICK CLOSE & HOUSE

Saltwick House stood in Saltwick Close in 1778. It was owned by Richard Ellison.

SANDESHAND = SANDSEND

This name occurs on old maps in place of Sandsend. Whether Sandeshand was an older name or a mistranslation is uncertain. Sandsend literally means the end of the sands. The village is actually in two parts, each with its own rivulet. The part nearer Whitby is referred to as East Row. The village had a railway station serving the Whitby to Middlesbrough route until the 1960s.

SANDEBECK

Sandebeck was the name given by Leland as the name of the river running out of Sandsend at the bottom of Lythe Bank.

SAXEBY

Saxeby was described as being in Fylingthorpe, in around 1350. It probably distinguished an original Saxon settlement from that of the Normans at nearby Normanby.

SCALMERIG = SHALMERIG = SHAUNRIGS

A rig or ridge opposite Cock Mill at Golden Grove.

SCAVENGER POSTS

These were places where scavengers (street cleaners) kept their barrows, brushes and shovels, and often deposited material such as horse droppings and leaves that were swept up and deposited in a big pile for recycling as garden manure. Scavengers were first officially appointed in 1764. The last

This old postcard, precisely dated 30 October 1914, shows the wreck of the hospital ship *Rohilla* near Saltwick Nab.

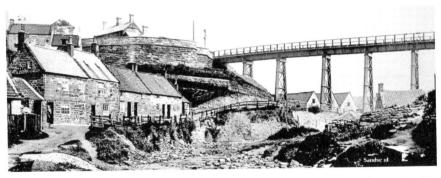

The old railway viaduct at Sandsend, now gone, was captured around 1910 in this long panoramic postcard of the time.

Another postcard illustrating the 'new houses' at East Row. The main road now covers the area of the narrower road and railway lines in the foreground.

Sandsend in the 1700s was still a working farm community, as can be seen by the haystacks in the valley leading to Mulgrave Woods.

remaining scavenger posts in Whitby were in Spring Vale behind a large stone wall near the base of the bridge carrying the former railway line to West Cliff station and one at the rear of St Hilda's Terrace.

SCOTCH HEAD

Nobody appears to know how Scotch Head got its name. A suggestion has been put forward that visiting Scottish boats paid harbour dues to moor there in the early herring-fishing days. Another theory links it to Scotching, a form of dressing stone in earlier days. Interestingly, in the early 1800s, a stonemason's yard stood close by on the site of the present amusement arcade. Scotch Head was a popular meeting place for suffragettes during the Victorian campaigns for women's votes. The suffragettes would meet here and then proceed to the beach, where they would hold fundraising events.

SEAMAN'S HOSPITAL

Though called a hospital, the premises in Hospitall (pronounced Hospit-all) Yards appear to have always been accommodation rather than serving any medical purpose. The present building was commenced in 1675/76, refaced in 1842 and refurbished in 1996. There is reason to believe that a medieval hospital (in the sense of a place to care for both the sick and travellers) may have stood on this site. The spelling of Hospitall Yards

(with two l's) could indicate a Knights Hospitaller connection. The Fleece public house opposite may have similar medieval origins, as the Order of the Golden Fleece was another order of chivalry that provided such establishments.

A gathering of suffragettes at Scotch Head. In the background work appears to be taking place on the harbour bridge.

A rare photograph taken on Whitby beach shows suffragettes holding a fundraising sandcastle-building competition.

SHAKESPEAR'S WALK

In the 1800s, this name was used as another name for Brunswick Terrace, the row of houses on the southernmost part of Brunswick Street, reached by steps from the main street.

SHAMBLES

A descriptive rather than official name for Sandgate when it was lined with butcher's shops, almost from end to end. A gutter ran down the middle and off towards the harbour to carry the blood from animals that were slaughtered on the premises.

SILVER STREET

Built in 1762, it was considerably widened at its Flowergate end in order to allow carts to access it some time in the 1800s. Its name origins are not recorded.

SKATE LANE = SKATE GATE = SCHATGATE (1417)

These are all are old names for Brunswick Street. It once veered in a slightly different direction and crossed the top of Flowergate in a continuous road leading across the present Cliff Street. It is also likely that it continued down Pier Lane and along the Crag, which was also anciently named 'Skategate'. There is speculation that it may originally have been a straight, steep bank leading in a direct line from what is now the junction with Flowergate and emerging at what is now Wellington Road.

A theatre, which replaced the old playhouse in the Paddock, stood in Skate Lane but was later burnt down.

SKINNER STREET

History tells us that it was purchased and built upon by William and John Skinner. It is interesting, however, to note that in 1292 a Thomas Skyn owned land here.

SLEGHTS = SLEGGITS = SLEIGHTS

The name is Scandinavian and means sledges, probably refering to wooden sledges pulled by beasts of burden that transported stone or wood down Sleights Bank to the river. Sled Gates, close to Skelder on the Whitby to Middlesbrough road, got its name in this way. An alternative explanation

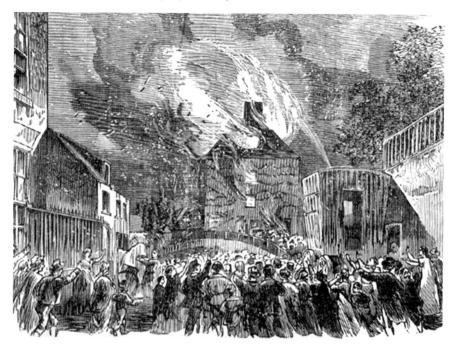

Skate Lane Theatre was built in 1784. It was later destroyed by fire in February 1853.

is that the name comes from the Norman *sletta*, meaning a piece of flat ground generally used for sheep grazing, though this is unlikely as the village is actually set on a steep slope. The name occurs throughout Britain in this context, often in field names.

SMUGGLERS CAFÉ = SHIPPE LAUNCHE = GREEN MAN?

This ancient building, previously known as the Shippe Launche Inn and reputedly the Green Man, was once connected by a smugglers' tunnel to the former Cutty Sark (since renamed the Tap and Spile, and now known as the Station Inn). Evidence of the tunnel was discovered in recent years. Another tunnel, running along the back (north) side of Baxtergate, was uncovered some years ago when construction of the present Boots chemist took place. The two were probably connected and may well have once emerged (as local legend says) under the font at the independent chapel next to the Sutcliffe Gallery in Flowergate.

SNEAE TOWN = SNETON = SNEATON

Sneaton was the site of the original Sneaton Castle, whose scant remains (a low mound) are almost obscured behind a farm on the left as you enter the village. The village name appears to mean 'snow town', being a

Right: According to this vintage postcard, Ye Olde Ship Launche Inn, now the Smugglers Café, was once the haunt of the local press gang.

Below: Old Sneaton church as it appeared in an eighteenth-century engraving. It was rebuilt in 1823.

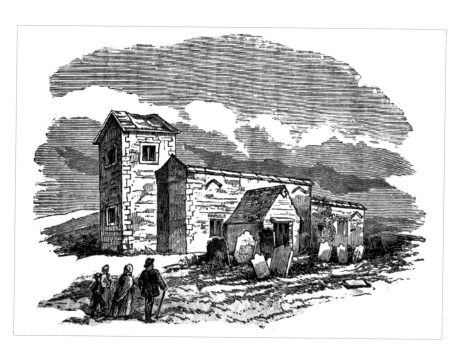

reference to the fact that in winter, snow always falls here before it does in Whitby, giving an early warning to residents who can see the village and surrounding area from the town.

SOUREBI = SOURBY = SNEATON THORPE = SNEATONTHORPE

The name is related to Sour Grif or Sourgryff, an ancient name for the small valley separating Sneaton and Normanby/Hawsker. 'Sour' was used in former times to mean harsh or rough. Coupled with the ending 'by', the name would seem to describe an early rough settlement. The term 'grif' or 'grave' meant a dwelling place.

SPITAL BRYGD = SPITTLE BRIDGE (1740) = SPITTALL BRIG (1816) = SPITAL BRIDGE

The name derives directly from a medieval hospital (actually a combined inn and hospice) run by one of the military/religious brotherhoods that stood here. Such hospitalls (with two l's) were run by the Knights Hospitaller, the Knights of Lazarus, the Knights of the Golden Fleece and other orders. Historically, we are told that the hospital was dedicated to St John, indicating that it may have been a Hospitaller establishment, though in reality it may have changed hands between one or more chivalric orders in its history. An ancient story records that it was originally built by Orm in 1109 to house a leprous monk from Whitby Abbey. In 1130, the master of the hospital was Robert de Alnetto, otherwise known as Robert d'Alney. It stood on the south side of old Spital Bridge (the small one still in situ) close to the water's edge. In 1816, remains of the hospital were still visible. The land was then owned by William Skinner and John Holt Jnr, who discovered three cellars of hewn stone. One was 10 feet by 5½ feet square with a doorway only 4 feet by 2 feet in size. The second was 2½ feet by 5 feet by 5 feet with a door 3 feet by 2 feet, and the third was almost a 4-foot cube with a door 3½ feet by two feet. In the last of these mentioned it was stated that 'there have been concealed two presses, the roofs and floors are formed by flat stones'.

SPITAL CLIFF = SPOUT CLIFF

The area to the south of Spital Beck (California Beck) is marked on various old maps as Spout Cliff or Spital Cliff. This area was the site of the town gallows at a time when all towns had to provide such a 'convenience'. The area is still called Gallows Close (colloquially Gallus Close) by locals, though the name does not appear on modern documentation or maps. The question 'Do you know where "Gallus Close" is?' is often used as a kind of 'citizenship

test' by locals to determine if someone, particularly an 'incomer', is truly 'qualified' as a local or not. An alternative origin for the name Gallus Close is that it was a chicken farm, the word *gallus* being Latin for cockerel.

SPRING VALE

The spring of water that gave the area its name was once used as a public well. It was situated in a field on the ridge overlooking the south side of Spring Vale. Another spring used as a water supply emerged from the bottom of the gardens behind what is now the Conservative Club, and yet another fed a small pool in a wood.

SPRYNG HILL

This has no connection with the modern street known as Spring Hill, which takes its name from actual springs of water, but was instead a hill in the Wragby area that in 1541 was owned by Richard and William Askwith. In 1778, the hill was described as being 'not far from Thorneybrow', formerly known as Thornelay.

STABLE COURT (1857)

An area that was later built upon to make way for the former Mount School. It later became part of the school playground.

STEAMBOAT LANDING

The name was a colloquial one. Steamboats docked at both sets of steps on either side of what is now Marine Parade. The Steamboat Packet pub and the Steamboat Temperance House were situated in Haggersgate in 1831 and 1851 respectively.

STEYNSIKER = STAINS ACRE (1775) = STAINSACRE

References to this village go back to ancient times. The name means 'stony acre'.

STAITHES = SEATON STAITHES (1400s)

The village, once a safe haven for smugglers, is on the east side of the beck, while Cowbar (pronounced 'cowb'r') occupies the other side. The original name of Seaton Staithes means 'Sea Town landing quays' and appears in lists of English *vils* between 1450 and 1462.

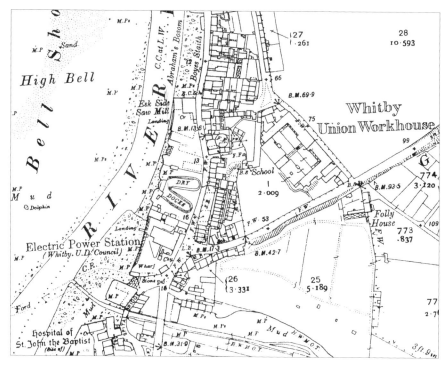

A Victorian map of the Spital Bridge area, including the workhouse, Folly House, medieval hospital site, Bell Shoal, Abraham's Bosom, Boyes Staith and Esk Side Sawmill.

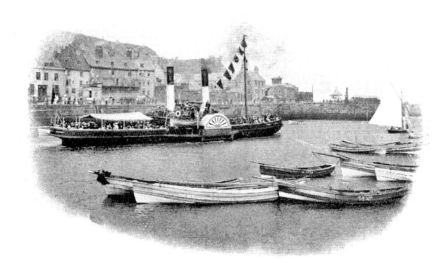

Prior to the First World War, a number of steamboats, including the *Emu*, regularly sailed from Whitby to Scarborough and other nearby ports.

STAXBY (1541) = STAKESBY

Stakesby was still considered a separate village until the early 1960s, and hosted the annual Whitby Agricultural Show on the town's Show Field. This now serves predominately as a sports ground. The village of Stakesby (previously divided into High and Low Stakesby) was known by this name in earlier times when it was part of the abbey lands. It presumably took its name from a stock or ancient milepost, which pre-dated the mile cross, the scant remains of which still remain near the wall outside the Lidl food store. This store was built in recent years on the site of Handyman Stores, which had occupied the former Whitby laundry site. Only the base of the old cross remains and has become part of Whitby legend under its more modern name of the 'wishing chair'.

STEPNEY

A farm (now the Jehovah's Witnesses' Kingdom Hall) and an area of land situated around what is now Whitby Town Football Club. The word 'Stepney' appears in a number of geographical locations throughout Britain and appears to be connected to stepping stones or stone-clad causeways used by packhorse carriers. However, historically, the first reference to the name in Britain is in the Bishop of London's estate of Stybbanhythe (*c.* 1000). This name developed through history as Stubanee, Stibanhe, Stubbanheth and finally Stepney in the sixteenth century.

STOCKTON WALK

Stockton Walk stood on the western corner of Brunswick Street and Flowergate, where the raised garden of the Little Angel public house now stands. Photographs of it were taken by Frank Meadow Sutcliffe, though a tale tells how, because he left it until near evening, he was unable to capture on film the religious frescoes that were discovered on its interior walls before they were demolished. The discovery of these frescoes gives credence to the theory that an old chapel attached to Whitby Abbey may have stood on the site and indeed it is a remote possibility that some kind of abbey building was here, giving its name to the later Old Abbey Inn next door. The name Stockton is unexplained in this instance, other than by the possibility that a stone stock or cross may have stood nearby. Pedestrians walking down Brunswick Street can still catch a glimpse of part of a church-like mullion window on the bottom corner of the Little Angel stonework.

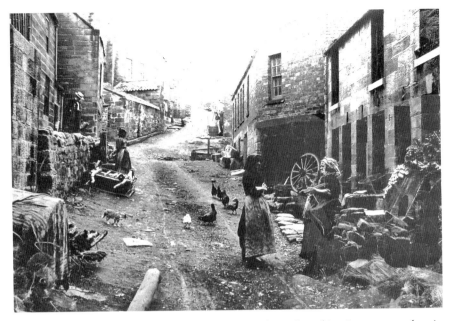

The village of Staithes was rarely visited by outsiders when this picture was taken in the late 1800s.

The Wishing Chair is actually the base of the ancient abbey mile cross. Its modern equivalent can be seen behind it, on the opposite side of the road.

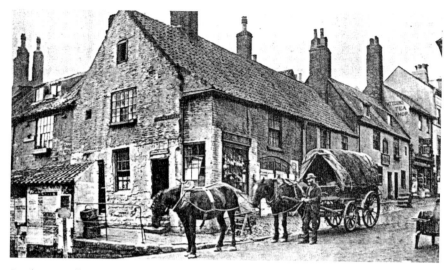

Stockton Walk prior to demolition. Behind the cart is the Little Angel with the Old Abbey Inn next door, near the horse-mounting block.

STOMPIE CLOSE

In 1541, it was described as being of 20 acres. The name was retained at least until 1778. It was then described as being on the west side of the Knolles between Lathe Close and the Robin Hood's Bay road. The original name is perhaps derived from Stumpy Close, an enclosed field full of tree stumps.

STONE QUAY (1700)

Stone Quay was an old stone quay at the bottom of Waterstead Lane. From here a wooden footbridge, removed in 1630, followed the route of the ford across the harbour from Boghall to Spital Bridge. It was later built upon and incorporated a dock and 'Mr Boulton's Quay'.

STOUP CLOSE = STOWPE CLOSE & STOUP BROW = STOWPEBROW = STOUPE BROW (modern)

Records from 1541 tell us that land here was owned by William Lockwood, and by William Cockeryll and Richard Redman in the same year. The word 'stoup' or 'stoupe' locally refers to a spring or source of water and occurs in a number of names such as Stoup Cross Farm, Stoupe Beck, and Stoup Bridge. The term is also used for a church font or water basin. The 'Township' of Stoupe Brow was described in a nineteenth-century guide as being reached 'along the sandy beach, under a high and steep cliff,

to which the sea flows as the tide advances; and the passage is unsafe'. Another nineteenth-century book gives more information:

The residence of Sunderland Cooke, Esq. is at Stoupe hall, in this township. The height of Stoupe Brow is 893 feet, and few appearances in nature are more awfully grand than the view from its summit. As the declivity of Stoupe Brow is impracticable to carriages the main road from Whitby and Robin Hood's Bay to Scarborough lies over the moors, in some places near the edge of the cliff. On this road, in the year 1809, there happened an accident ... A lady and two young gentlemen, travelling in a post chaise to Scarborough, the driver, on some occasion, alighted, and the horses, being left to themselves, immediately struck into a gallop. Before they had proceeded far, both the horses and chaise fell over the cliff, down a tremendous precipice of nearly one hundred feet high, and of which about forty feet next to the bottom is a perpendicular rock. In its fall, the chaise turned over three times, yet neither the horses, the chaise, nor the passengers suffered any injury, except that the lady received a trifling scratch on the face, and the party immediately proceeded to Scarborough.

STREONSCHALCH (Bede) = STREONSHALL = STREONSHALE (Anglo-Saxon Chronicle) – and various spellings

The origin of the ancient name for this settlement at Whitby has never been agreed on by historians. However, like the name Whitby itself, it is likely that the name may have been brought here by earlier Scandinavian settlers. A place near the modern Norwegian port of Larvik was anciently called Skiringssalr (Shining Hall), and was pronounced in almost the same way as Streonschalch. An alternative suggestion is that the name came from Steona's settlement, Streona being a ruthless turncoat warrior from the Viking period.

SWEET GALE VALLEY

An area full of Sweet Gale bushes which grew in the damp ground at the foot of the Whitby side of Pond Hill on the Whitby to Scarborough road. The valley was drained, ploughed and cleared around 1970, destroying the natural habitat of the Sweet Gale (Bog Myrtle), which had long been gathered there by generations to make into a heady, aromatic beer.

TANNERY (WEIGHILLS)

Weighill's tannery buildings appear to have been located both at the top of the present Mayfield Road and later at Bog Hall. One or both of these was later taken over by Cook's Tannery and was listed as such in 1928. A public well was situated behind the Bog Hall Tannery.

TENTER CLOSE = PADDOCK

The present Paddock was probably much larger at the time it was called Tenter Close. Until the early 1960s, it was still an actual paddock used for grazing horses. Its former name is derived from the A-shaped tenter frames used by fullers and dyers to dry their cloth. A well existed here in the small garden at the side of the former salerooms that has recently been converted to private dwellings. It was described as being at the end of Hunter Lane. The salerooms themselves were originally built as the town playhouse in 1763 and stood next to Mr Hunter's house (hence Hunter

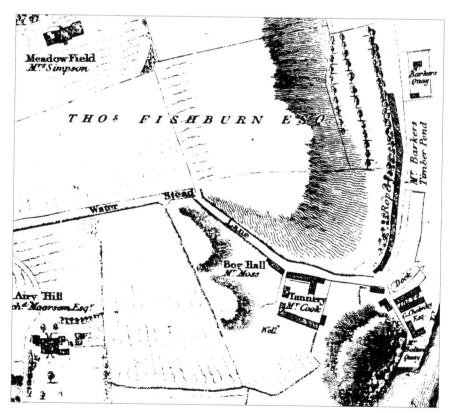

Bog Hall Tannery can be seen on this nineteenth-century map, with what was formerly Stone Quay (right) at the bottom of Waterstead Lane.

Lane). The disused theatre building was later used as a malt-kiln by John Ellerby, who also used the buildings along the eastern side of the Paddock as a brewery. He would take his carts down the cobbled road that winds around the buildings down to Cliff Street. This road was still used in the 1960s by motor traffic, especially in summer when it served as a shortcut to avoid the long queues of visitor's cars entering Cliff Street during the holiday season. This little cobbled roadway appears never to have been decommissioned as a public highway, though it has been fenced off by residents from time to time.

THINGWALLA = TINGWALL = TINWALL

The seat of the earliest Viking local government in Whitby was named the *Thingwalla*. Tradition tells us that this was in the Potato Market area of Church Street. Early sixteenth-century maps of the town do indicate that the earliest settlement in Whitby was centred on the east side of the river, south of the present bridge.

THEATRES & CINEMAS

COLISEUM

The former 'Star' group cinema named after the famous Coliseum was originally built as a temperance hall. After closure as a cinema, it became a bingo hall but ceased this function in March 1996. Network took over the building shortly afterwards and have once more installed a small cinema here.

EMPIRE

Originally known as the British Empire Electric Theatre, it later became the Empire Cinema and now houses a Boyes store. When the building was being converted into a store, large rings were discovered on the cellar walls that were once used for tying up boats, showing that the area was tidal in earlier times. Though a lock-up or jail did once exist on this site, the rings were not used for restraining prisoners, as was speculated at the time.

FREEMASON'S TAVERN

This was a theatre built at the Freemason's Tavern in Baxtergate to replace the one destroyed by fire in Skate Lane (Brunswick Street). It too was burnt down.

THE PLACE FOR QUIET EVENINGS

THE EMPIRE—
Was Designed and Built to be only a Picture House, and is therefore Perfectly Ventilated, Free from Draughts. Comfortable.

THE PROGRAMME—
Is carefully chosen each week, to include a complete change every Thursday from the World's Finest Motion Pictures, Pictures which please everyone's taste.

EMPIRE
PICTURE HOUSE.

Continuous Performance 6.45 to 10.30 p.m.
Matinee Saturdays at 2.30.

STATION SQUARE, WHITBY. WEST HODGSON. Manager.

THE COLISEUM, WHITBY,
YORKSHIRE.

SEASON COMMENCING WHIT-MONDAY,
EVERY EVENING AT 7.30.

LESLIE FULLER
PRESENTS THE FAMOUS

PED'LERS

PERFECTION—REFINEMENT—LAUGHTER.
A VAUDEVILLE MUSICAL MELANGE.
INCLUDING WELL-KNOWN LONDON ARTISTS.
Cosiest Theatre in Town. Well Ventilated. Constant Change of Programme.

An early advertisement for two of Whitby's cinemas reminds us that the Coliseum was still in use as a theatre in the 1930s.

GRAPE LANE

A small theatre used by travelling players was once situated in a room above the large double-fronted shop (formerly Hodgson's) at the Church Street end of Grape Lane. The tiny platform stage was still in existence in recent years.

PADDOCK PLAYHOUSE

Playhouse Steps, leading from Cliff Street to the Paddock, take their name from Whitby's first playhouse or theatre, which once existed in the former Paddock salerooms (private dwellings, since 2010).

SKATE LANE (BRUNSWICK STREET) PLAYHOUSE

See under FREEMASON'S TAVERN.

WATERLOO

Waterloo Place and Waterloo Yard, situated at the junction of Brunswick Street and Flowergate, are supposedly named after the Battle of Waterloo. The yard leads northward and once terminated at a house with Waterloo Meeting Hall adjoining. This hall later became the Waterloo Cinema, popularly referred to as the Bughouse because of its run-down state and its seats that were repaired with wood from orange boxes. It was popular for its back-row double seats designed for courting couples. After its closure, the building was briefly used as

an indoor market before standing empty. It was demolished in the late 1990s to make way for housing. A passageway at the eastern side of the house near the cinema was used as a right of way to the Paddock until the 1960s.

THORDISSA = THORDSAY = THORDESAY

This is the ancient Viking name for East Row, Sandsend. A temple to Thor was said to have existed here. In Roman times the temple, or an alternative one, was dedicated to Mars, giving its name to nearby Marsdale. Thordissa Beck, also known as Thordsay Beck and Thordesay Beck, now has the modern name East Row Beck and is crossed by the stone bridge at the eastern end of Sandsend, which replaced one washed away by floods.

TOLL BOOTH

This was a kind of ancient town hall where taxes were collected, market tolls were paid and the local court met. Whitby's first recorded toll booth stood close to the end of what is now Grape Lane, Church Street, where the Vikings set up their *Thingwalla* or seat of local government in the town. In 1640, a 'more modern' toll booth was built here and lasted until its demolition in around 1788, when transactions were transferred to a new town hall built further up Church Street in the Market Place.

TUCKER'S FIELD

The fields belonging to a Mr Tucker, whose farmhouse was situated on the present West Cliff School playground. The site was left by Mr Tucker to the people of Whitby for recreational use.

TURNPIKES / BARS

Turnpikes or toll roads that ran into and out of Whitby were controlled at turnpike gates or bars, one of which stood on Mayfield Road (then known as Baulby or Bauldeby Lane) close to the former Hunter's garden nursery. The nursery lands became part of the present housing estate, but had previously been proposed as the site of a large supermarket.

In around 1760, this turnpike ran from Bagdale as far as Bar Farm, Saltersgate, with a booth being recorded at Sleights Bridge. Another booth may have been in place at the Castle Park end of the road known locally as the Switchbacks, but having the official name of Cross Bar Lane.

It is known that the upper part of Flowergate (now St Hilda's Terrace) was also levelled out to make a turnpike, but whether tolls were ever charged is doubtful. Green Lane was supposedly made a turnpike in 1752,

when tolls were limited to two pence for any class. Another toll booth stood on the Whitby/Sandsend road (the only alternative route being along the seashore at low tide); the booth is now a private dwelling, standing almost opposite the entrance to Whitby Golf Club.

UGLEBERDESBI = HUGHBARDESBY = UGGLEBARNBY

First mentioned in the *Domesday Book* as Ugleberdesbi, its original chapel is believed to have been built in 1137 by Nicholas, Abbot of Whitby, with the assistance of a freeholder named Ralph of Hugebardeby (possibly Ralph or Radulph Eversley). It was demolished in 1872 when the present church was built. The village name appears to mean Hugh's or Uglebard's settlement.

UPGANG

This name, probably of Scandinavian origin, means 'the way up'. From time immemorial the road from Sandsend passed along the beach towards Whitby via Upgang, and appears also to have been part of the 'Jackass Road' route from Whitby prior to 1670.

UPPER BAULBYS

Only a house now bears this name recalling an area that was once part of Balby Closes (now the Mayfield Road area).

UPPER SKINNER STREET

In 1817, Poplar Row was said to 'have various names but no fixed name'. One of these was Upper Skinner Street.

WALKER'S SANDS

A name given to an area of sand that stretched from Bagdale Beck to Boghall. It probably took its name from a local resident, owner or shipbuilder.

WATERING LANE = WATER LANE = WATERSTEAD LANE

Waterstead Lane was once a 'water lane', i.e. a lane with water running over its surface to the river from a spring situated close to the present ambulance station. The spring was open until the 1960s, but was capped when road alterations took place. Another spring at the bottom provided water for a tannery. Part of the old tannery buildings is still standing, close to the footpath to the new high-level bridge.

TOLL CHARGES
 s d
Two Wheels & One Horse. 3
Two Wheels & Two Horses. 4
Two Wheels & Three Horses. 6
Four Wheels & One Horse. 6
Four Wheels & Two Horses. 8
Four Wheels & Three Horses. 10
Four Wheels & Four Horses. 1/
Motor Cars. 1/
Horses, Bicycles, Etc. 1
Cows, Sheep, & Pigs. 2 each.
The Owners of this Road will not be
Responsible for any Accident
which may Happen hereon.

 s d
Three Wheeled Motor Car 9
Motor Cycle & Side Car 4
Motor Cycle 2

The private dwelling still to be seen on the Sandsend road was once the house where tolls were collected for using the Whitby to Sandsend section.

This apparently insignificant, tiny, nineteenth-century illustration, when enlarged, revealed the old Upgang slipway road to Sandsend, the former Mulgrave Castle Inn at its summit, and a quay.

WATERLOO WELL

This public well was once situated in Factory Fields, but is now lost under the Auckland Way housing estate. Like Waterloo Yard, it probably took its name from the Battle of Waterloo (1815).

WAYNEGATE

It is described mysteriously on page 102 of Gaskin's *The Old Seaport of Whitby* as being 'the east boundary of Bagdale'. A Wayne or Wain was a farmer's open wagon, while 'gate' derives from the Viking *gata*, meaning an entrance or way.

WAYZGOOSE

Sometimes assumed to be place names, e.g. Egton Wayzgoose, Sneaton Wayzgoose, etc. The Wayzgoose was in fact the annual outing of the *Whitby Gazette* printers to various villages and locations within the Whitby district.

WES(S)ELDEN BANK (1775) = SWINEGATE (1737) = HORSE WYNDE (1750s)

This thoroughfare, used by horse and donkey traffic, eventually became part of Boulby Bank.

WEST CLIFF FIELDS

West Cliff Fields were bought for the building of the West Cliff development by George Hudson's Company in 1848.

WEST CLIFF SALOON

West Cliff Saloon was an old name given to the original Spa theatre and dancehall buildings. The gardens were fenced off and a charge made for admission. A well-known eccentric, the Reverend Hayden Williams from Flowergate chapel, regularly campaigned against the fencing off of public areas in order to charge admission. On one occasion he encouraged locals to tear down the Saloon garden fences and on another to pull down a newly built wall around the abbey. When Williams appeared in court for assault against a police officer, the sympathetic judge asked him: 'But you didn't mean to do him any harm did you Mr Williams?' In his typical fashion, Williams replied: 'No sir, in fact I meant to do him a lot of good!'

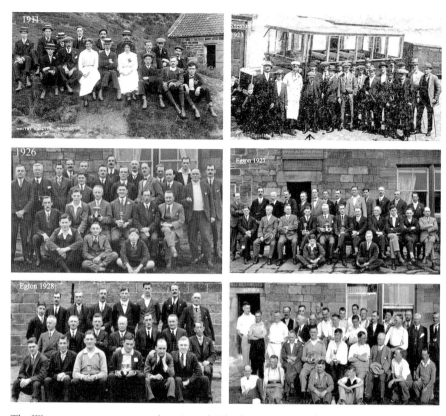

The Wayzgoose was an annual outing of *Whitby Gazette* staff. As can be seen, workers chose various destinations during the years from 1914 to the 1930s.

WEST CLIFF STATION

A former branch railway station on the Whitby to Middlesbrough coastal line, now a housing estate. The name Station Road (a continuation of Argyle Road) remains as a reminder.

WEST LEA

West Lea achieved fame as one of the first buildings to be hit during the 1914 bombardment of Whitby from the sea. The owner of the house was in the bathroom at the time and his wife was downstairs. Both were unhurt.

WHARF HOUSE

Wharf House was the premises of Thomas Hawxwell, a jet ornament manufacturer. It was situated in Imperial Yard, near No. 66 Church Street, during the period 1890–99.

WHARREL / LONING (1530 to early 1900s) = ABB CHURCH LANE = CHURCH LANE = JACKASS ROAD = LONING = WHARREL LONE = DONKEY ROAD

This hill runs parallel to the 199 steps from Church Street in its steep climb up to the abbey. It was called the Wharrel or Wharrel Loning as far back as 1530. The word 'Lone/Loan/Loaning/Loning' is an old term used in Britain, particularly north of the Humber River, meaning an enclosed roadway, often between hedges, which led to a church or churchyard.

WHARREL CLOSE

Described in 1541 as 6 acres on the north side of Horse Close, it was still known by this name in 1778 when Richard Ellison owned it.

WHITBY

The origins of the name have never been agreed on by historians, many favouring White Bay, Hvita's homestead or White Abbey. It is, however, interesting to note that Visby, the capital of the island Gotland (similar to Goathland), was once spelt Wisby and a number of villages on the island have similar sounding names to villages around Whitby, including Slite (Sleights). Visby's oldest church, like Whitby's, is named St Mary's, while Visby's main street, High Kirkgate, uses the same name once used for Church Street. Though the evidence is only circumstantial, it gives credence to the theory that Vikings from Visby may have settled here, bringing local names with them. The town's population appears in 1301 to have consisted of about 100 houses and was about the same in 1540, being no more than a large village. By 1610, the population rose to about 1,500 and grew to 2,500 by 1650. It then increased steadily until 1700, when about 3,000 people lived here. Another Whitby was built in Tangiers, Morocco, by local men. An account of this can be read in most editions of *Whitby Lore & Legend* by Shaw Jeffrey.

The other English Whitby (Wirral, Cheshire) is directly linked to our own (see WHITBY HALL below).

WHITBY HALL = ABBEY HOUSE

The original Abbey House has a long history dating back to the days of Hugh Lupus, Earl of Chester, who constructed a building, Whitby Hall, in Cheshire. The town of Whitby in the Wirral, close to Liverpool, serves as a reminder of this.

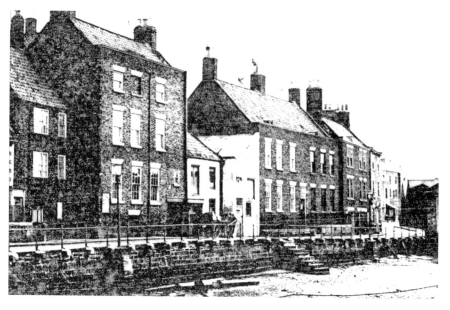

Above: Wood's Quay in earlier times. A cart can be seen outside what became the Esk Brewery, which was later rebuilt to become the present fruit and vegetable warehouse.

Left: A portrait of Joseph Wood, one of the town's prominent merchants, who gave his name to Wood's Quay.

WHITBY SPA

Originally a 'spaw' or spa of medicinal waters sited on the East Cliff at the end of Haggerlythe. It gave its name to the Spa Ladder walkway from the East Cliff to the East Pier that was demolished 2001, when the new sea defence works were undertaken. Another spa was situated at the foot of the West Cliffs on the beach just east of the tunnel entrance to the Spa Lift. Associated buildings stood close by in the early 1800s, but were severely damaged in a storm and were never rebuilt. Victoria Spa is still in existence, functional but unused. It occupies a rounded building which, though once in an open garden, now hides itself at the back of Broomfield Terrace.

WHITE HORSE AND GRIFFIN

This pub had a reputation for being frequented by a wealthy clientele. Both Captain Cook and Lewis Caroll are said to have been among its customers. Caroll famously described the oyster shell grottoes behind it in a letter. The Griffin formed part of the crest of the Cholmley family.

WOOD STREET = WOOD'S QUAY = WOOD'S STAITH = JOSEPH WOOD'S STAITH

Wood's Quay was a once isolated wharf at the bottom end of Church Street. It stretched from what is now Boulby Bank to the entrance to Salt Pan Well Steps. The quay later became part of the present road. It is said to have taken its name from property owner Joseph Wood, one of the town's burgesses, who died in 1738.

YARD

In Whitby, a yard is not a backyard (which is almost always specifically referred to as a backyard), but is instead a long, narrow alleyway, generally leading from one thoroughfare to another. It takes its name from the fact that before standard building regulations, it was common practice to leave a 1-yard (3-foot) gap when erecting a new building next to another, thereby preserving a right of way.

YBURN

The old name for Iburndale, which in the early 1800s was described as 'a single house in the township of Ugglebarnby'.